IMAGES
of America

STRUTHERS REVISITED

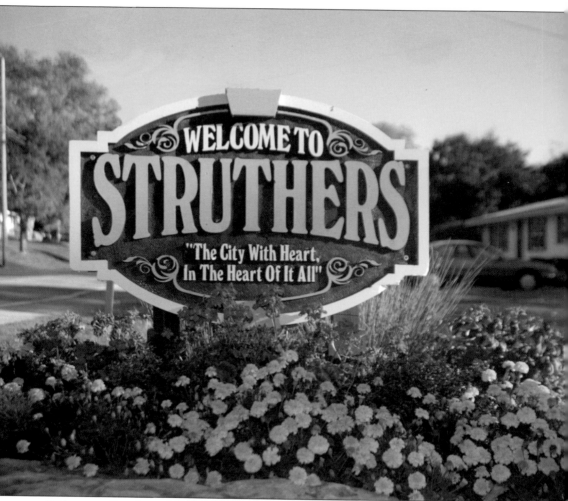

Welcome to Struthers, "the city with heart in the heart of it all." (Courtesy of Frank Marr.)

IMAGES
of America

STRUTHERS REVISITED

Patricia Ringos Beach in association with
the Struthers Historical Society

ARCADIA
PUBLISHING

Published by Arcadia Publishing
Charleston, South Carolina

Printed in the United States of America

Library of Congress Control Number: 2015933212

For all general information, please contact Arcadia Publishing:
Telephone 843-853-2070
Fax 843-853-0044
E-mail sales@arcadiapublishing.com
For customer service and orders:
Toll-Free 1-888-313-2665

Visit us on the Internet at www.arcadiapublishing.com

This book is dedicated to 286 Hopewell Drive, the house that built me.

CONTENTS

ACKNOWLEDGMENTS

When you talk, you are only repeating what you already know;
but when you listen, you may learn something new.

—Dalai Lama.

As I complete *Struthers Revisited*, I am reminded that "it takes a village to write a book." A thank-you is owed to the Struthers Historical Society. The care that you take of the history of our town is equaled only by your generosity in sharing it. In particular, Marian Kutlesa, thank you. Unless otherwise noted, all photographs are from the society's collection.

The support I received as the book developed was an incredible gift to me. Pat Bundy, Denise Collingwood, Dominick Commisso, Dick Dale, Marian Kutlesa, Frank Marr, Gary Mudryk, and Debbie Zetts never allowed a question or request to go unanswered.

Struthers Revisited went through several drafts thanks to extraordinarily generous readers. Thanks go to Pat Bundy, Michael Buchenic III, Denise Collingwood, Dick Dale, Cynthia Ringos Donahue, Paula Ringos Drapcho, Laddie Fedor, Marian Kutlesa, Dan Mamula, Sue Pitcher, and Emmalee Torisk.

To everyone on these pages representing Struthers, thank you. In many cases someone took the time to search through old family photographs and share stories. For the time they took to help, I want to acknowledge Julia Amicone, Dan Becker, Martha Bishop, Anne and Teresa Boano, Kathy Brantley, Christine Roskos Cavalier, Annette Todeska Ciccoelli, J.P. Daliman, Roger Day, Betty Kossick DeCesare, Gil Frank, John Gingery, Nancy Johngrass, John Kerlek, Marianne Daliman Kieffer, Nancy Tobias Knight, Bob Komara, Robert Kurtz, Dan Mamula, Ed Marsh, Doris Matricardi, Harold and Linda Milligan, Sue Missik, John Morell Jr., Janet Morris, Bill O'Hara, Jeff Pantall, Joe Paris, Judy Kurtz Sabula, Dennis Smith, Terry Stocker, Debbie Volsko, Esther Watts, Gregg Wormley, Gene and Rose Yuhas, and William Zaluski.

A thank-you is given to Jesse Darland, my title manager at Arcadia Publishing, whose assistance proved invaluable.

This book is intended to add to the history documented in *Struthers* (2008) and not be repetitious. I apologize in advance for any errors and regret that there are photographs and stories that, because of the constraints of space, could not be in this book.

Finally, thank you to my husband, Dan, for your patient and constant love and support.

INTRODUCTION

"The city with heart in the heart of it all." The Struthers motto is deceptively simple. It encourages and supports while progressing forward and embracing change—it is familiar and uncomfortable. Perhaps no other century depicts this better than the 20th century. It was a time of change.

In the early 1900s, instant coffee, tea bags, Vick's VapoRub, and Jell-O came to market. The electric washing machine and electric toaster were invented. The bicycle was a cheap form of transportation, and automobiles were a fantasy for most Americans. The city of Struthers was then known as Marbletown. Only after Thomas Struthers bought back the family homestead to honor his father and brought railroads and industry to town, sometime around 1903, was the town name changed to Struthers by popular vote. In 1900, Youngstown Iron Sheet and Tube Company was established.

In the 1910s, the world's largest and most luxurious ship, *Titanic*, hit an iceberg on its maiden voyage from Southampton, England, to New York City just before midnight on April 14, 1912, and more than 1,500 people died in the frigid Atlantic Ocean in the worst maritime accident ever. In 1919, Congress passed the 18th Amendment making the manufacture, sale, or transport of intoxicating liquors illegal. Struthers enforced Prohibition, but when it ended in 1933, it issued Rip's Restaurant the first liquor license.

In the 1920s, the stock market crash in 1929 devastated economies around the world, leading to the Great Depression. Banks collapsed, and about a quarter of the American workforce could not find jobs. Not being able to get money from the banks to buy your children shoes also hit Struthers. Many local businesses, like Begalas's Grocery Store and Milligan's Dairy, helped families in need.

In the 1930s, Disney introduced its first animated motion picture, *Snow White and the Seven Dwarfs* (1937). Although records are lost, it probably played at the Ritz Theatre in downtown Struthers. Germany invaded Poland in 1939, setting the stage for World War II. Lou Gehrig, the Pride of the Yankees, retired July 4, 1939, having played in 2,130 games over 15 seasons as a Yankee first baseman; he died of amyotrophic lateral sclerosis (ALS), today also known as Lou Gehrig's Disease, in 1941.

In the 1940s, Warner Brothers introduced animated characters Elmer Fudd, Bugs Bunny, Daffy Duck, Porky Pig, Sylvester, and the Road Runner to television. December 7, 1941, the Japanese attacked Pearl Harbor, drawing the United States into World War II. On June 6, 1944, D-Day, 300,000 Allied troops landed on the beaches of Normandy, France, re-entering continental Europe and taking a big step toward ending the war. Many young lives from Struthers were lost in the wars of the 20th century.

In the 1950s, on Thanksgiving Day 1950, snow started falling in Struthers, and over two days, it developed into one of the town's worst blizzards. *I Love Lucy* premiered in 1951 and was the number one comedy show within six months. NBC offered regular color television programming in 1953. Dick Clark premiered *American Bandstand*, and Elvis Presley entered the rock-and-roll

scene in 1956. The hula-hoop was introduced in 1958, and the Barbie doll by Mattel Toys in 1959. North Korea invaded South Korea on June 25, 1950, and 54,000 Americans died before the peace treaty was signed July 27, 1953. Dr. Jonas Salk licensed a vaccine against polio in 1955. Alaska became the 49th state on January 3, 1959, and Hawaii the 50th state on June 27, 1959.

In the 1960s, Harper Lee wrote *To Kill a Mockingbird* (1960) and won the 1961 Pulitzer Prize for Fiction. In the 1960 election, presidential debates were televised for the first time. The young Democrat, John F. Kennedy, defeated Richard Nixon in both the debates and the election. Lee Harvey Oswald assassinated him on November 22, 1963, in Dallas, Texas. The Beatles from Liverpool, England, appeared on *The Ed Sullivan Show* in 1964. In 1965, US military bases in Vietnam were attacked. About 600 million people watched their televisions on July 20, 1969, as astronauts Edwin "Buzz" Aldrin and Neil Armstrong landed on the moon and Michael Collins stayed aboard *Apollo 11*. Struthers residents watched these events with great interest, feeling the pain, triumph, and rock-and-roll.

In the 1970s, the Watergate burglary of the Democratic Party's national headquarters occurred. Stephen Wozniak and Steven Jobs designed the Apple I in Jobs's California garage. Following the local bicentennial celebration, the Struthers Historical Society formed to keep the town's collection of memorabilia intact. In 1977, Alex Haley's *Roots* aired as an eight-part TV miniseries. Also in 1977, Bonnie Beachy became the first Struthers athlete to score 1,000 points playing basketball, young Robert De Niro and Meryl Streep came to town to film *The Deer Hunter,* and later that year, the Youngstown Iron Sheet and Tube Company announced its closing.

In the 1980s, the United States boycotted the 1980 Olympic Games in Moscow because the Union of Soviet Socialist Republics had invaded Afghanistan. On July 29, 1981, the world watched the fairy-tale royal wedding of Prince Charles and Lady Diana Spencer. In 1979, Iranian terrorists had taken over the US embassy in Tehran, taking 52 Americans hostage; they were released in 1981. In 1982, Michael Jackson thrilled with *Thriller,* the best-selling album in history. On January 28, 1986, the *Challenger* space shuttle exploded, killing all seven crew members. Through hard work and initiatives like CASTLO and MRCO, Struthers continued to rebuild following the loss of steel industry jobs.

In the 1990s, *The Simpsons* debuted in 1990. On April 19, 1995, the Alfred P. Murrah Federal Building in Oklahoma City was struck with a car bomb; Timothy McVeigh was later convicted and executed for this attack, which killed 168 men, women, and children. *Seinfeld,* "the show about nothing," aired its final episode after nine seasons in 1998. Construction of a new bridge across the Mahoning River was scheduled for completion and to be opened in 2000.

These 20th-century highlights illustrate that as the world was entertained, it was devastated; as it achieved, it saw crumbling downfalls. As the century closed, nothing was as certain as change. Spam was a can of meat. There were cordless phones and mobile phones but no cell phones. People had cameras, but their phones were not yet cameras.

Struthers Revisited uses pictures to capture the memories of life in the last century. It is a scrapbook with narrative to complement the photographs. The chapters People; Places; Parks, Pools, and Parades; Protecting; Providing; and Playing for Sports and Fun tell stories selected to represent a common experience. Some are hallmark events, but many others depict everyday life. Each day makes up a life and is the thread that weaves the fabric of a story. In some cases, these images are the only ones that remain from a time past and are preserved in the Struthers Historical Society's archives.

Events and time changed Struthers, but Struthers did not collapse under their weight. "The city with heart in the heart of it all" is alive and well.

Struthers Revisited is for the men and women who have lived, loved, and worked there yesterday, today, and tomorrow. A town's history is more than any one book, and any text falls short. But it is my hope that this book will continue to preserve pieces of history. As John Lennon said, "You may say I'm a dreamer but I'm not the only one."

One

PEOPLE

If you want to go fast, go alone. If you want to go far, go together.
—African proverb

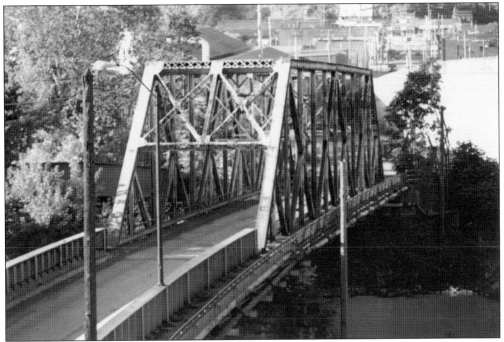

Struthers's progress in the 20th century was a result of community. This chapter is a sampling of the lives that touched Struthers, with stories selected to resonate. This early bridge crossed the Mahoning River carrying automobiles and pedestrians until it closed at the end of the century.

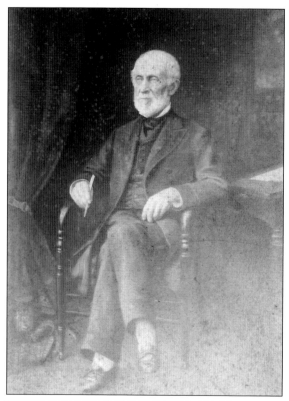

Thomas Struthers (1803–1892) was the sixth child of John and Mary Struthers. Born in Ohio, he grew up working on his father's farm in the summer and attending school in the winter. Later, he moved to Warren, Pennsylvania; attended Jefferson College; and became a lawyer. He was successful in real estate, and in 1865, he purchased all the property that had once been his father's, laying out the village of Struthers. The Struthers family's first cabin was built above Yellow Creek near the Mahoning River. Local lore tells of an earlier fort erected on this overlook that was later the site of St. Nicholas Church.

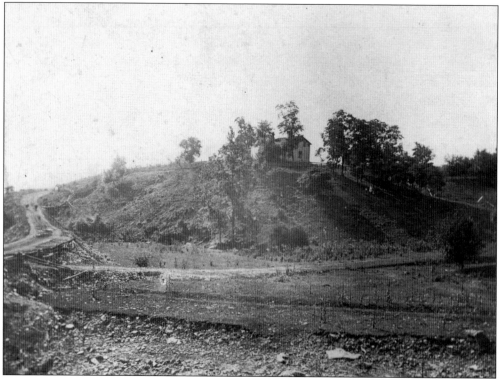

Into the 20th century, the city grew, and people worked, lived, and celebrated. Sometimes, finances were a struggle with many recalling taking boarders into their homes. Three boarders might even share the same bed while working different shifts. The women took in washing and ironing. And there were happy times. Here, in a backyard party on Center Street, Frank and Mary Mohar mark their wedding anniversary. (Courtesy of Cikulin.)

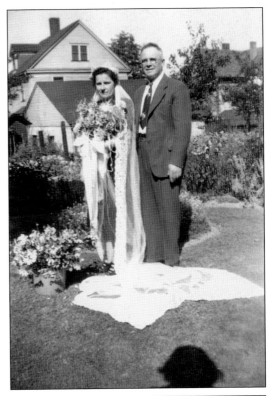

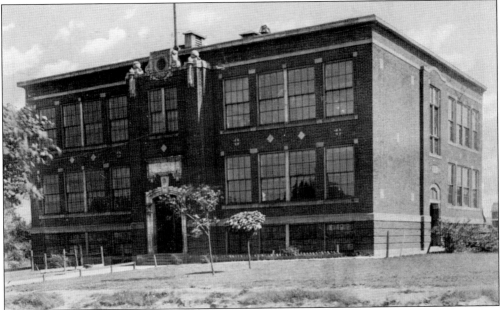

In the 1900s, Struthers immigrants' roots were particularly deep. All groups were determined that their children be educated. Here is one of the earliest schools, South Side School, or Sexton Street School, opened in 1914. Indoor restroom facilities were added in 1918. In 1920, national attention focused on the Struthers School System when half-day sessions were initiated to relieve overcrowding. Students went a half-day, six days a week, until the new high school opened in 1921.

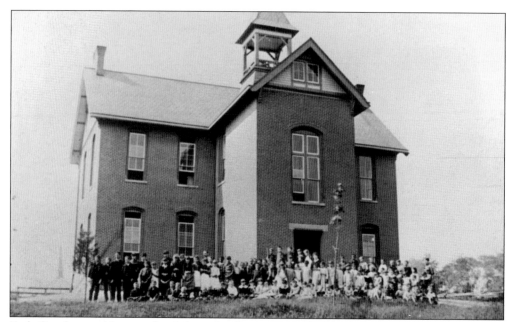

Early Struthers residents realized that schools were more than buildings representing the means by which formal education and not-so-formal socialization occurred. Students entered, progressed, and graduated; teachers came and left; buildings changed. This 1906 picture shows the first Elm Street Grade School. A larger school on the corner of Elm and Terrace Streets, where the current Struthers City Administration Building stands, replaced it. In the early 1920s, the school changed to the high school and then an elementary school again. Finally, it was used as a community center before being demolished in 1955.

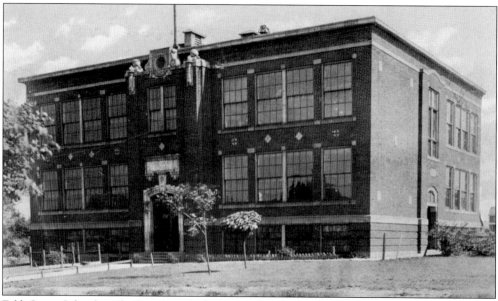

Fifth Street School was built in 1928 for $150,000 and was opened in 1929. There were renovations to the school in 1955, 1991, and 2002. Fifth Street School, originally a neighborhood elementary school, became Struthers Middle School in 1993, housing all students in grades five through eight. Current enrollment is over 630 students.

Center Street School, the elementary school pictured here, opened in 1917, having been built at a cost of $40,000 to serve children in Nebo. Upgrades began in 1918 with the passing of a bond issue to provide an indoor bathroom system to replace the outdoor privies. A gymnasium was added in 1958–1959. The school was demolished in 2003. In 1897, the National Parent Teacher Association was founded by Alice McLellan and Phoebe Apperson Hearst. More than 2,000 parents, teachers, workers, and legislators attended the first meeting in Washington, DC. The name was changed in 1908 to the National Congress of Mothers and Parent-Teacher Associations. An early Parent Teacher Association at Center Street School is pictured at right. Seated from left to right are Suzie Delost, Principal Polen, Anna Kossick, and unidentified. (Above, courtesy of Marian Kutlesa; right, courtesy of Betty Kossick.)

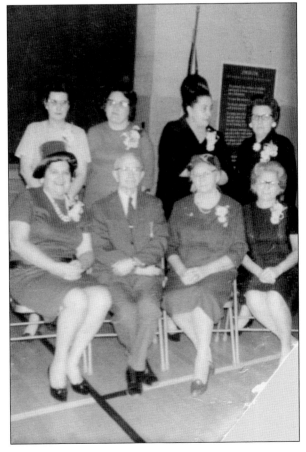

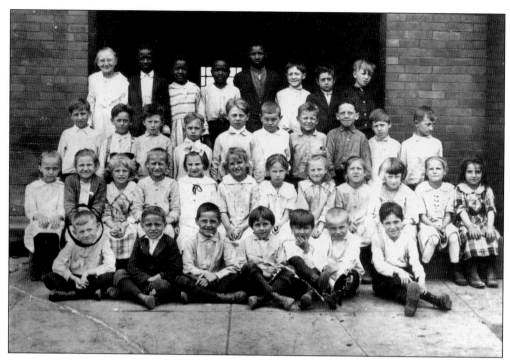

North Side School, or Highland Avenue School, was built with bonds passed in 1908. Built for $25,000, it was in operation until 1978. This is a 1918 class picture. Used as a middle school for the district in the 1970s, it was closed in 1978. The building still stands and houses studios and other small businesses.

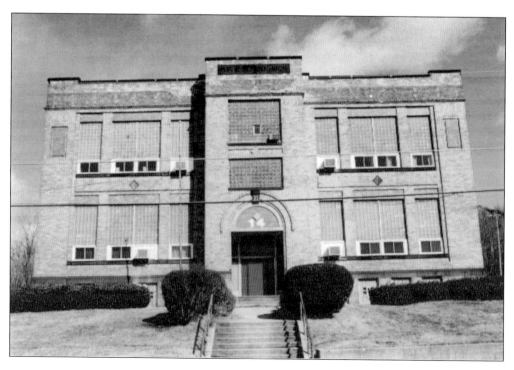

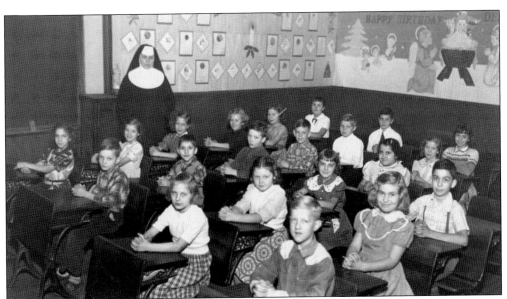

Also in the north side of Struthers was Holy Trinity Grade School. It was built in 1910 on Washington Street and attracted students from Campbell, Coitsville, and Lowellville. Students attended daily Mass. The school had two buildings, and the one across the street from the church had four classrooms without indoor plumbing, forcing the students to cross the street to use the second-floor girls' bathroom or the third-floor boys' bathroom in the other building. Pictured above are Sister Ursula's third-grade and fourth-grade students. With the building of the new church at the top of the hill on North Bridge Street, the school also moved in 1960. Below, Father Sofranec and the Boy Scouts raise the flag at their new school. Holy Trinity School closed in 1991. (Both, courtesy of Holy Trinity archives.)

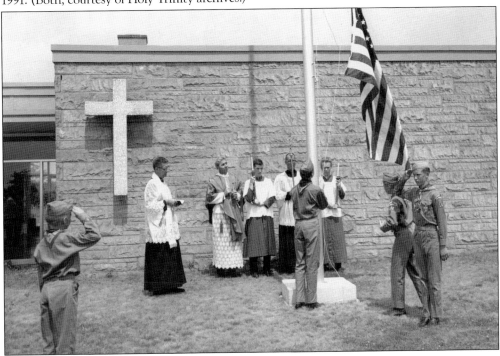

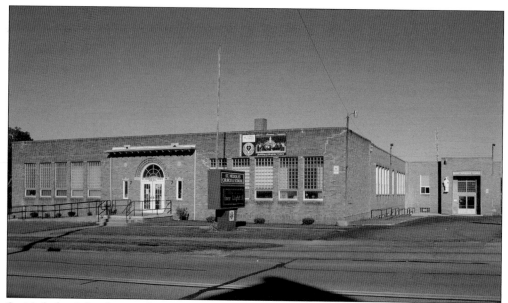

St. Nicholas School opened as a parish school in 1928 and was staffed entirely by sisters of the Ursuline Order. As enrollment increased through the years, more Ursuline sisters, as well as lay teachers, joined the teaching staff. Additions to the building to accommodate the growing enrollment were completed in 1950. Students from Youngstown neighborhoods Brownlee Woods and Buckeye Circle also attended. It is now one of seven campuses of the Lumen Christi Catholic School System. (Both, courtesy of Frank Marr.)

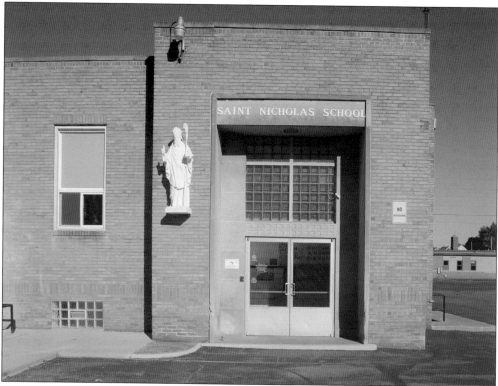

Lyon Creed School on Elm Street, pictured above as a new building, was built in 1915 as an elementary school. It was for a time later in the century used as a middle school. The class picture below is of Lyon Creed teacher John Daliman with students in 1968–1969. These students would eventually be part of the 1973 graduating class of Struthers High School. Lyon Plat School on Ninth Street was built in 1959. It contained 10 classrooms, a stage, gym, and administration suite. Both schools have been demolished. (Below, courtesy of J.P. Daliman and Marianne Daliman Kieffer.)

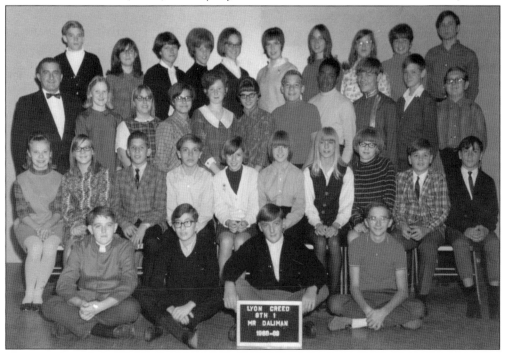

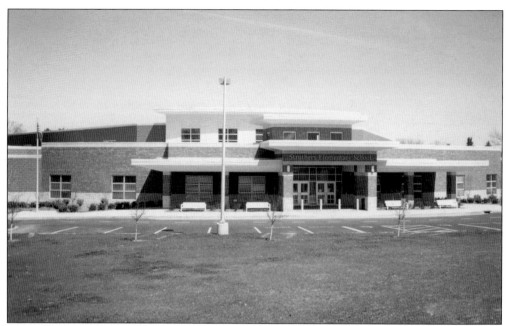

The history of the Struthers City Schools is rich with neighborhood elementary schools. Lyon Plat, Center Street, Sexton Street, and Manor Avenue Schools were the last four neighborhood schools with students in kindergarten through the fourth grade before merging to become Struthers Elementary School. By 2002, the public grade schools in Struthers were consolidated. Students now attend Struthers Elementary School on Ninth and Elm Streets, where the baseball fields were earlier. (Courtesy of Laddie Fedor.)

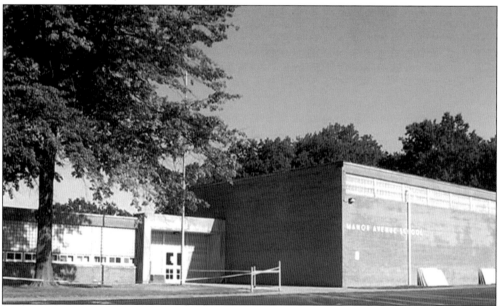

Manor Avenue School opened in 1959 as the last of the old grade schools built for the Baby Boomers. Students attended from the southwest part of the city, including neighborhoods toward Lake Hamilton. It was during this time that residents recalled the mass polio immunization program in the schools.

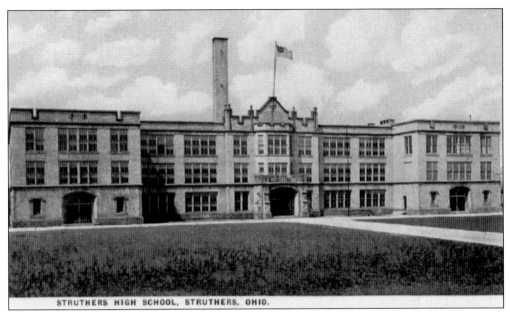

STRUTHERS HIGH SCHOOL, STRUTHERS, OHIO.

Above is an early picture of Struthers High School before the field house was built. When opened, the school on Euclid Avenue had 30 rooms on three floors. Grades seven, eight, and nine were on the first and second floors; grades 10, 11, and 12 were on the third floor. The class of 1922, with 21 graduates, was the first to graduate from this new high school. In fact, throughout the country, high schools were rare before the 1920s. Those who went on to higher education generally went from grade school to college. The Struthers High School yearbook also evolved over the decades and underwent several name changes. The earliest was *The Owl*, then *The Omega* began in 1930. After not too many editions, it became and remains *The Hopewell*. In 2003, the building was demolished. (Below, courtesy of Dan Mamula.)

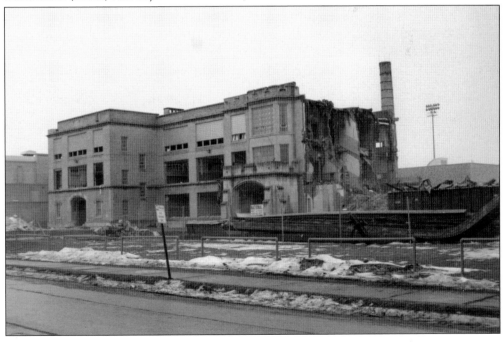

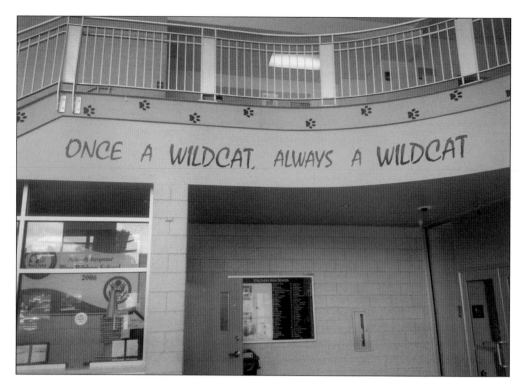

Although the yearbook title has changed and the building is new, the alma mater is unchanged: "Through the halls of Struthers High School, loud our praises ring. For to this our Alma Mater, always we will sing. Here's to Struthers, hail to thee, now we pledge our loyalty. And we trust we'll ne'er forget you, true to thee we'll be." Walking into the new high school, the time-honored motto, "Once a Wildcat, always a Wildcat," rings true for many alumni. (Below, courtesy of Frank Marr.)

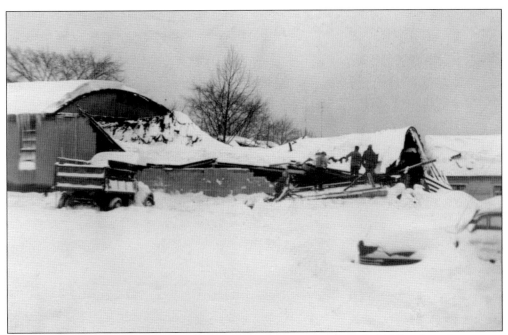

During the 1950 blizzard on November 24–25, Struthers's snowfall totaled 20.7 inches; that winter, the area received a total of 85.3 inches. Betty Kossick Decesare remembers being worried that she would not be able to get back to South Side Hospital and Nursing School. She walked from her home in Nebo to the police station and learned that an ambulance was coming to pick up a woman in labor on the north side of Struthers. She was able to hitch a ride to the hospital with the crew. Pictured below are Esther (right) and Carol Yauman playing in the snow on Fourth Street following the blizzard. The roof of McIntee Motors on Midlothian (above) collapsed under the weight of all the snow. (Both, courtesy of Esther Watt.)

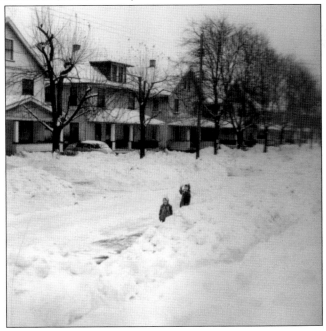

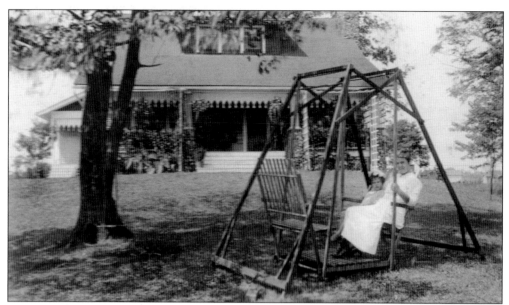

The Creed family made many contributions to Struthers. Mabel Lyon Creed (1908–2006) supported herself and her family during the Depression by catering and cooking; she became known for her chicken potpie. She later succeeded her father in real estate, developing residential and commercial areas in Struthers including the Lake Shore area at Lake Hamilton. In 1962, she built additions onto the family home, pictured above, to create Maplecrest Nursing Home. It remained family owned and operated until 1997. Mabel and Joe Creed had three sons, Tom, Bill, and Dick. Tom served as councilman before and after being mayor from 1970 to 1975, working to establish Struthers Manor on Poland Avenue, a high-rise complex offering affordable housing for senior citizens (below). He died in 2010. (Below, courtesy of Frank Marr.)

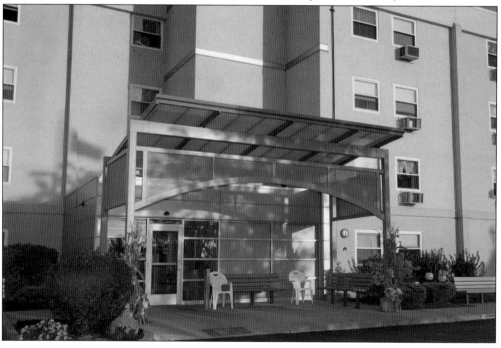

The Struthers Rotary was founded in 1955, and since 1984, it has awarded $80,000 in scholarships to graduating seniors who have served their community. Scholarships are funded by annual pancake and sausage breakfasts and flag flying. The current flag fundraiser is highly successful; 525 flags fly throughout the city on Memorial Day, Flag Day, Fourth of July, Labor Day, and Veterans Day after being installed by Rotary volunteers. Pictured below in 2014, Vivian Henderson is honored as a Paul Harris Fellow for exemplifying the rotary motto of "service above self." She has served lunch during rotary club meetings since its inception. From left to right are Tom Baringer, Dan Becker, Vivian Henderson, Mary Ann Morell, and Kelly Becker. (Both, courtesy of Frank Marr.)

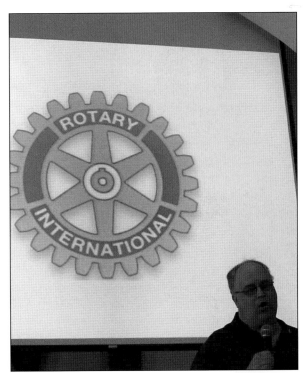

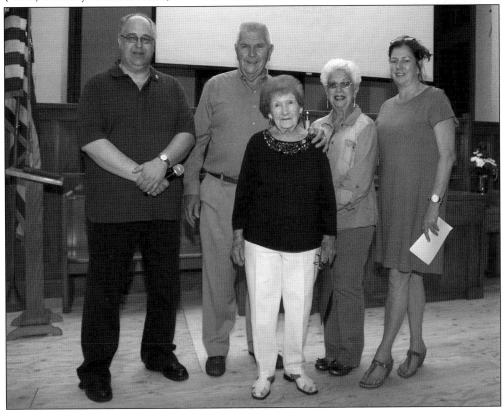

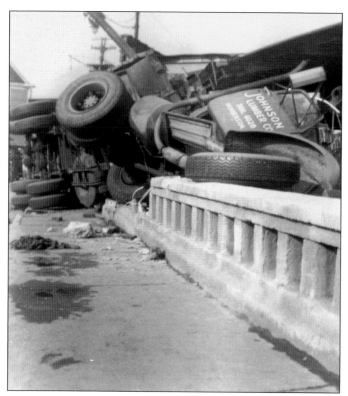

In 1957, a tractor trailer rig with a 55,000-pound load of lumber smashed into Thatcher Heating Company at 184 South Bridge Street and ripped out approximately 15 feet of the Lowellville Road Bridge when the brakes failed as the truck was coming down Bridge Street. Driver Paul Long of North Carolina was delivering to Yallech Lumber and was thrown about 30 feet into the dry bed of Yellow Creek, receiving only minor bruises. Owners of Thatcher Heating, George Voytella and Joe Ternasky, usually worked at night but had decided to take that night off. The shop section where they would have been working was destroyed. (Both, courtesy of Betty Kossick.)

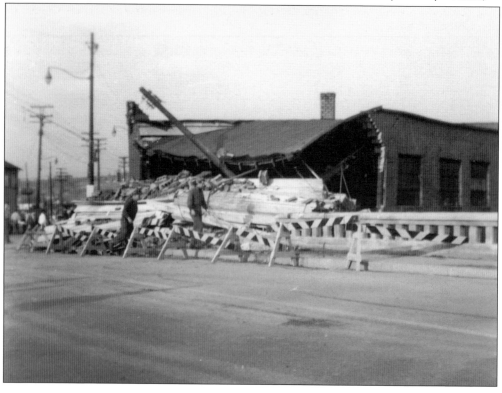

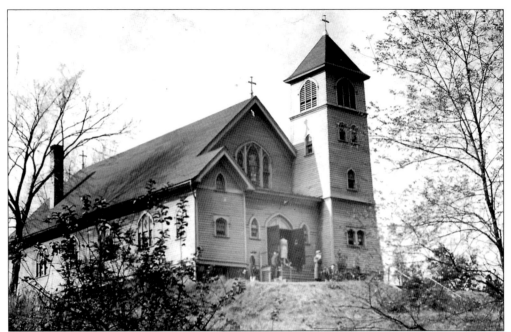

St. Nicholas Church was founded in 1865. First located on Bridge Street, a fire destroyed the tiny frame church in 1907. It moved to Lowellville Road, and in December 1944, an overheated furnace was blamed for completely destroying the second church building at a loss of $35,000. Above is the church on Lowellville Road before the second fire. The church is now located on Fifth Street and is a magnificent brick structure. In 2011, it joined with Holy Trinity Church to form Christ Our Savior Parish. (Above, courtesy of Frank Marr.)

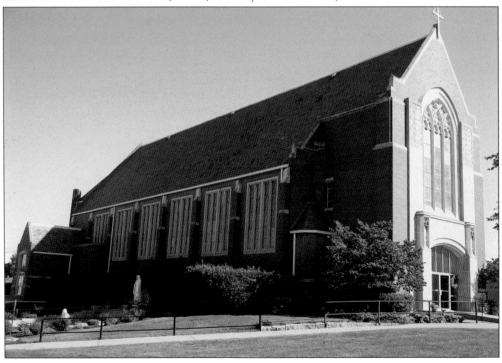

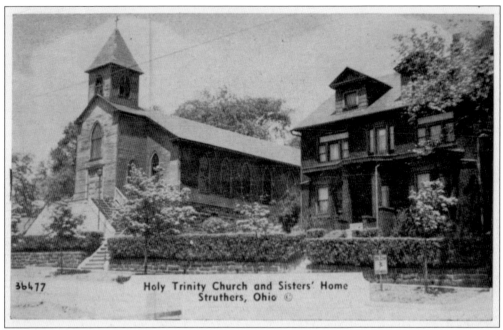

Holy Trinity Church and Sisters' Home
Struthers, Ohio ©

36477

Holy Trinity Church Parish was started in 1902 by Slovak Catholics in Struthers who had been traveling five miles to Ss. Cyril and Methodius Parish in Youngstown. Pictured above is the first church on Washington Street, built in 1907. It served the congregation for almost 50 years until 1954, when the hilltop site for the church was dedicated. Pirohy (also spelled pierogi) is a traditional food; members of the parish make it most Fridays. The dough dumpling may be filled with potato, cheese, cabbage, or lekvar. From left to right below are Carol Evans Grimm, Vivian Leko, and Ruth Geister "pinching" pirohy in the church basement. (Both, courtesy of Holy Trinity archives.)

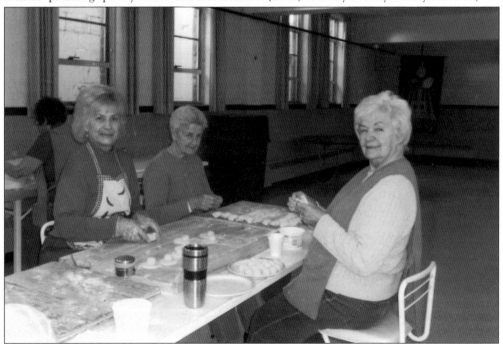

Christ Lutheran Church congregation, founded as a mission in 1919, built this church (above) in 1929. The mission had two pastors serving out of Youngstown, and in 1921, its status changed from mission to church. The beautiful brick church on Sexton Street was built with member contributions for $45,000. Gil Frank remembers that his father was not only a church member but also the church's carpenter, farmer, and janitor. As a little boy, he would accompany him to church early winter mornings to get the stove heater started before the congregants arrived. Below, a mid-century choir sings. (Above, courtesy of Marian Kutlesa.)

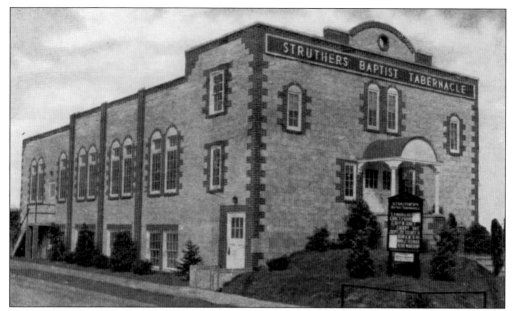

From modest beginnings in 1918 when six families met on the second floor of the village fire station, on Shaeffer Hill just below where Struthers Presbyterian Church is now, there have been three Baptist congregations in Struthers: Struthers Baptist Tabernacle on Elm Street (pictured here), First Baptist Church at Morrison and Ohio Streets, and Pilgrim Baptist Church at McClure and John Streets.

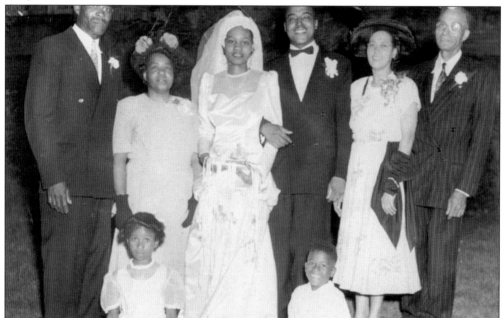

In 1920, Emma Gauge founded St. John African Methodist Episcopal (AME) Church, formerly Christ Memorial AME, on West Washington Street. Pictured here is the 1948 wedding of Naomi Wright and James Brantley at St. John Church. From left to right are (kneeling) Rhoda and Ronald Kelley; (standing) Thomas and Cora Lee (Cain) Wright, Naomi Wright and James Brantley, and two unidentified. (Courtesy of Kathy Brantley.)

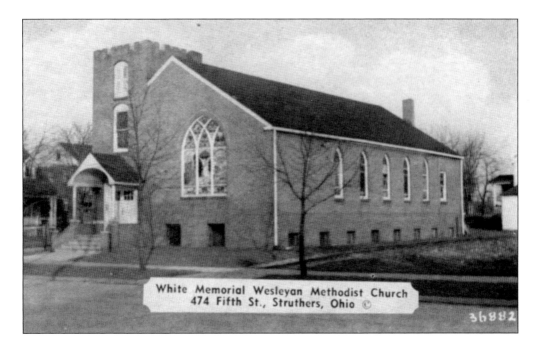

White Memorial Wesleyan Methodist Church
474 Fifth St., Struthers, Ohio ©

In 1886, a Methodist Society was formed in Struthers, initially meeting for services along the banks of Yellow Creek in the summer months. Two old postcards, part of the Struthers Historical Society's collection, depict these Methodist churches. Above is the White Memorial Wesleyan Methodist Church at 474 Fifth Street, and below is the United Methodist Church, formerly known as both the Struthers Methodist Episcopal Church and the Struthers Methodist Church, at Sexton and Stewart Streets.

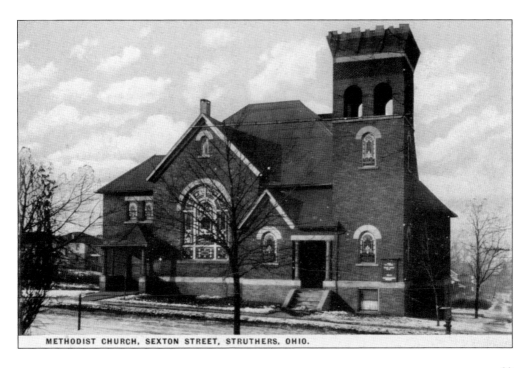

METHODIST CHURCH, SEXTON STREET, STRUTHERS, OHIO.

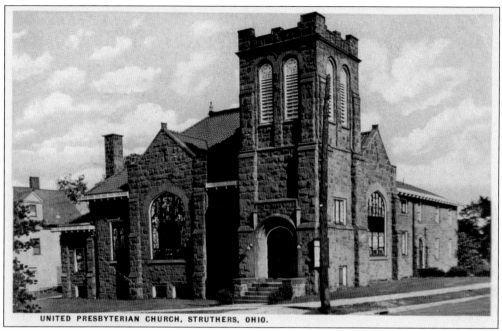

UNITED PRESBYTERIAN CHURCH, STRUTHERS, OHIO.

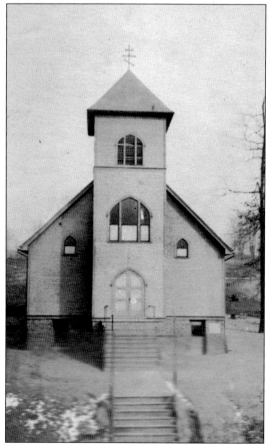

The Struthers Parkside Church on Poland Avenue is one of the oldest churches in Struthers, tracing its beginnings to Poland Center in 1804. It is where the founding Struthers family attended services. In 1849, the log church was replaced, and in 1884, the church was dismantled and moved to Struthers. A majestic stone building eventually replaced the older frame one.

The first frame church building for Ss. Peter and Paul Church on Frank Street was eventually replaced by a brick building for the Greek Orthodox Catholic Church. Later in the century, the congregation disbanded because of dwindling attendance. The church is now the Fellowship Church of God in Christ.

Struthers Friends of the North Side reunited with a brunch at the Oak View Pavilion in 1993. These pictures were taken at that first reunion. According to Gene Yuhas, seen above with his wife, Rose, "North Siders come together because everyone helped, and continues to help, each other." Coming from Germany, the Frank family owned 93 acres known as the old Snyder Farm between Frank Street and the Campbell line. Farming, parceling, and selling over the century helped establish the North Side neighborhood. Pictured below clockwise from rear are Emma Ceplece, Pete Ceplece, Doris Frank, Delores Frank, John Frank, and Gil Frank. (Both, courtesy of Gene and Rose Yuhas.)

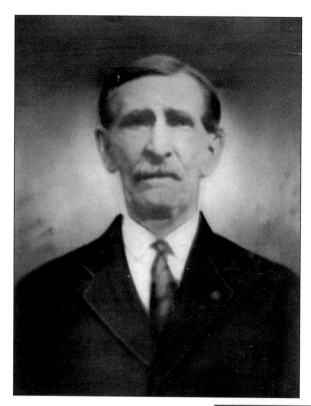

In 1862, Alexander Frankfort (left), the son of Struthers pioneer Adam Frankfort, enlisted in the 90th regiment of the Ohio Volunteer Infantry, participating in 27 Civil War battles during the three years he served. On his return, Alexander bought the site of his home at Poland Avenue and Terrace Street in 1884. This is where Alma (below), the oldest of his seven children, was carried in at two weeks of age. She lived there for 93 years. Alma became a well-known seamstress. Later, descendants of Frankfort donated this property to the Struthers Historical Society; it is where the society has been housed since 1986.

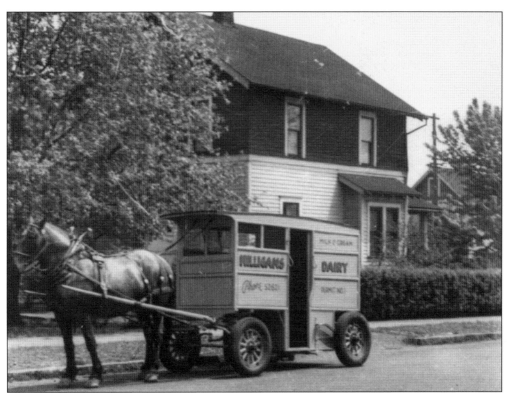

An African proverb states: "When an old man dies, a library burns down." Harold Milligan (1911–2013) was that library for Struthers. He was the first Struthers Eagle Scout and attended The Ohio State University, studying veterinary medicine at a time when tuition was $20 per quarter. Unable to finish school when the banks failed, he returned to Struthers to work in the family business, Milligan Dairy. Harold was married to the former Margaret Anderson for 77 years. They had three children: Harold Jr., Struthers fire chief (1980–2011); Rebecca; and Judy. Harold Milligan served as six-term mayor from 1952 to 1964, overseeing construction of the first sewage plant in Mahoning County. While serving on the Ohio Municipal League, he invited Sen. John F. Kennedy to address their convention in Akron. Milligan later declined a position in the Department of Transportation under President Kennedy. Harold was also a master gardener. (Both, courtesy of Harold Milligan Jr.)

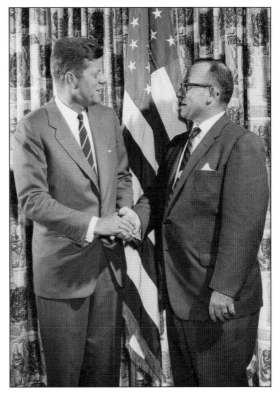

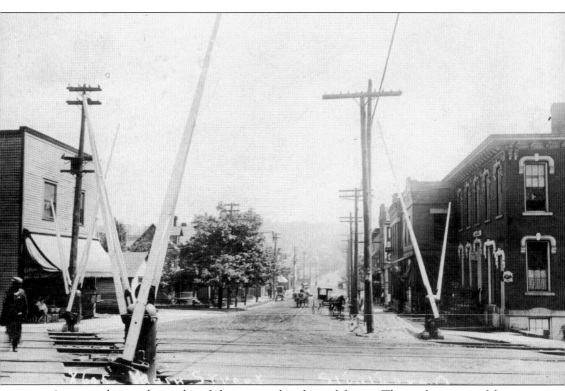

A century brings about a lot of changes, and so does a lifetime. This early picture of downtown clearly shows that although trains and the railroad had come to Struthers, the automobile had not. As seen here in 1908 with dirt roads and wooden sidewalks on the main thoroughfare, a horse and buggy still provided most of the transportation. That would be changing. In Muhammad Ali's words: "The man who views the world at 50 the same as he did at 20 has wasted 30 years of his life."

Two

PLACES

Do not go where the path may lead; go instead where there is no path and leave a trail.
—Ralph Waldo Emerson

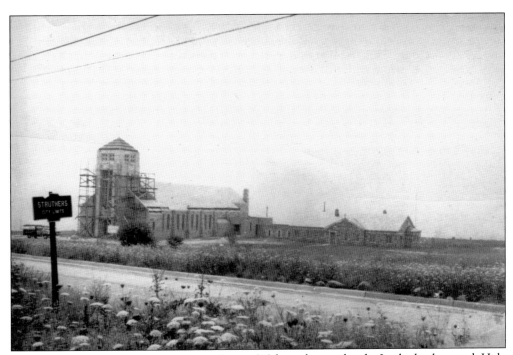

Here is one way into Struthers on State Route 616 from the north side. In the background, Holy Trinity Church is under construction. Other places of interest appear in this chapter in scenes from throughout the 20th century. (Courtesy of Holy Trinity archives.)

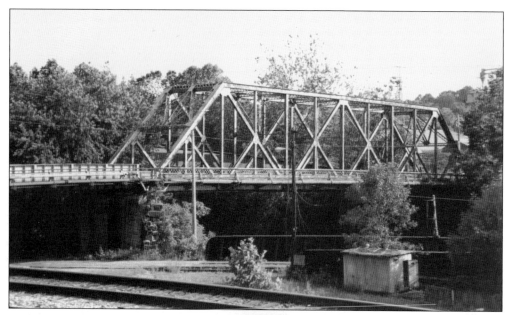

Traveling south into town on State Route 616, nothing has changed the face of Struthers more than the building of a new bridge across the Mahoning River. From the steep north-side hill, the old span frequently had traffic knotted waiting for trains. The steepness of the hill contributed to a serious accident in 1964. The brakes of the car that Robert and Daisy Collingwood were driving failed. As it traveled 300 feet down North Bridge Street and through the Broad Street intersection, the car picked up speed, flipping several times as it went across the embankment and railroad tracks. Robert died two days later of injuries sustained in the crash. Daisy lived to be 101 years old, dying in 1994. (Both, courtesy of Dan Mamula.)

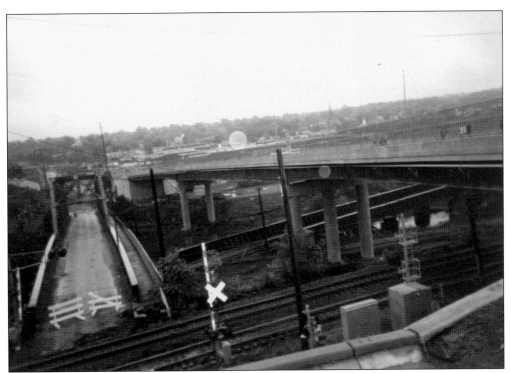

The progress of the bridge's construction was followed and documented visually by many people. The historical society has a large collection of these photographs. This project was monumental in both scope and outcome. It changed the scenery forever. The new bridge was heralded as a "testament to the future rather than a repeat of the past." Here are the old and new bridges side by side. (Both, courtesy of Dan Mamula.)

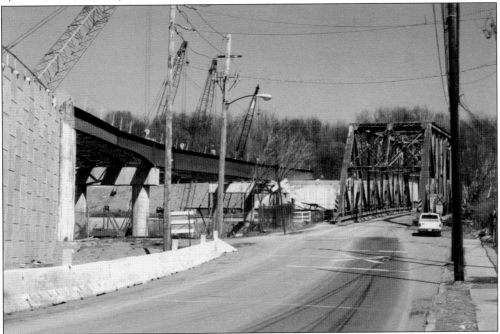

The official opening ceremony celebrating the new Korean Veterans Memorial Bridge was in 2000. Built over the river and the railroad tracks, drivers were no longer delayed by trains. Residents and those who regularly drove through downtown, where it is estimated that 10,000 to 12,000 cars travel daily, also celebrated this new structure. The aerial view below shows the traffic pattern and the dramatic changes that occurred in the landscape with the building of this new bridge. (Below, courtesy of Dan Mamula.)

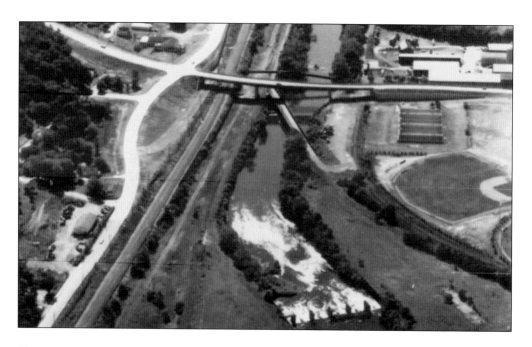

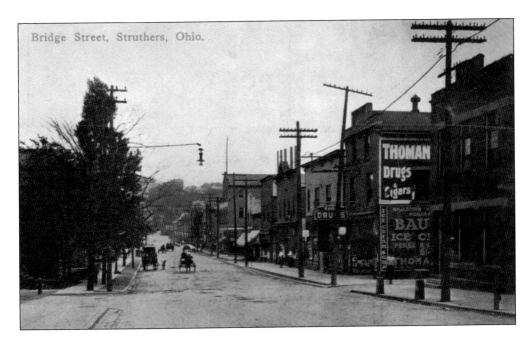

Bridge Street, Struthers, Ohio.

Here are pictures of downtown Struthers around 1908, when the horse and buggy was the mode of transportation. The Central Union Telephone Company established telephone lines in 1903. It cost $1 a month for a party or shared line and an additional 50¢ for a private or individual line. In Struthers, the company started with 80 phones. Ed Marsh recalled that his dad had the only phone on Prospect Street and neighbors would come over when they had to make a telephone call. The exchange was located in the A.M. Lyons Building, with Ella O'Malla starting as the first day operator and Alice Mounds as night operator.

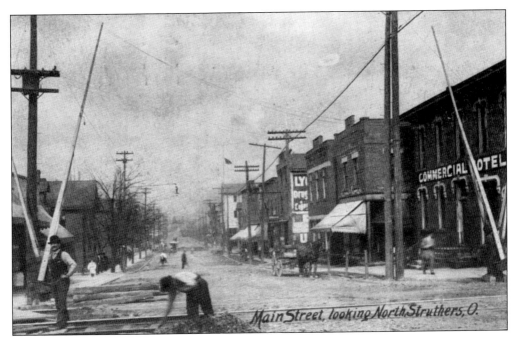

Main Street, looking North, Struthers, O.

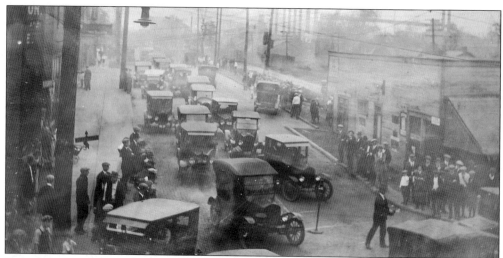

Streetlights were first gas powered, but it was difficult to keep them filled. In 1902, Marshall George Demmel became the city's first police officer and was paid a little extra to add this to his responsibilities. As early as the 1920s, automobiles had taken over Struthers, as seen above at the busy intersection of State and Bridge Streets. Struthers, with a population of 11,240 in the 1930s, had very little crime. Police chief Harry Davis credited his force of seven policemen, demographics, and geography, saying, "We don't have holdups because our business section is between two railroads and . . . we haven't any of what you might call society folks . . . times have been hard, we don't have much money here." With the automobile came gas stations. Pictured below is Milt Sauer's gas station in 1939, located at Poland Avenue and Terrace Street. (Below, courtesy of Esther Watt.)

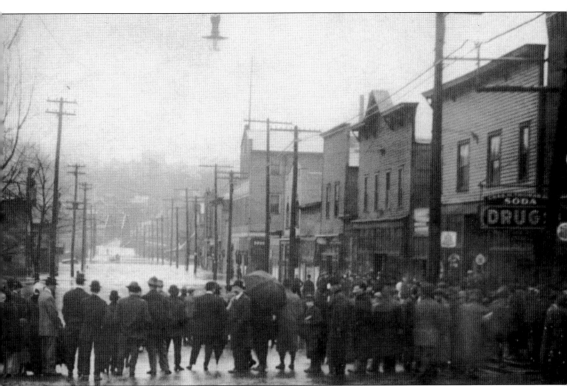

Ohio's largest weather disaster was the flood of 1913, when the Mahoning River crested at 22 feet. Rain began on Easter Sunday, April 23, falling "steadily at a monotonous pace" for over 48 hours. Hurricane-force winds, rain, and flooding resulted in 428 statewide deaths primarily because of a lack of an advance warning system. Throughout the state, surging waters toppled bridges, hampered rail transport, cut communication lines, and broke through levees. In Struthers, eight-year-old Stanley Persing, son of John and Mary Persing, drowned when the riverbank where he and friends were playing collapsed. Although some area homes suffered losses, the industries along the river incurred extensive damage. There, the waters stood several feet deep on the mill floors, covering machinery and furnaces. Here, a crowd looks north toward the river and bridge.

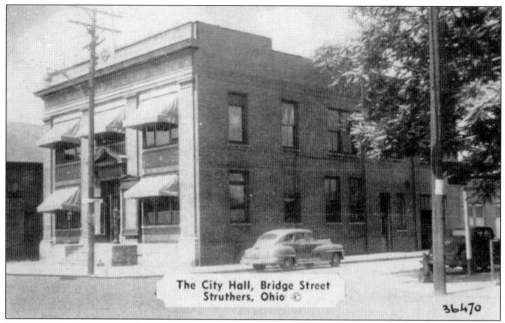

The City Hall, Bridge Street
Struthers, Ohio ©

36470

Pictured above is the old city hall building that was located on Bridge Street in downtown Struthers. In the early part of the century, it had one of the few phone lines in the city. Wives looking for their husbands would call asking for someone to check the bar across the street and "please send him home." The city administration building at 2 Elm Street opened in this location in 1976. Struthers's mayors in succession are as follows: Thomas Roberts, 1902–1905; John Stewart, 1906–1907; A.B. Stough, 1908–1917; Horace Wilson, 1918–1923; Hans Johnson, 1924–1927; T.A. Roberts, 1928–1939; William Strain, 1940–1945; Thomas Needham, 1946–1951; Harold Milligan, 1952–1963; Bruce Papalia, 1964–1964; Joseph Opsitnik, 1964–1965; Stanley Davis, 1966–1970; Thomas Creed, 1970–1975; Anthony Centofanti, 1975–1979; Daniel Hurite, 1979–1983; Howard Heldman, 1984–1991; Daniel Mamula, 1992–2007; and Terry Stocker, 2008 to present.

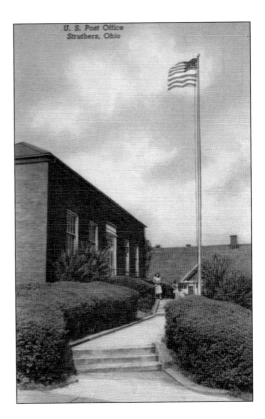

U. S. Post Office
Struthers, Ohio

In 1938, the post office opened in this new building (right) on South Bridge Street. In 1878, the town's first post office was located in Parker's drugstore, moving at least twice before a permanent home was built. Home deliveries were initiated in 1921, and until the mid-1950s, they were made twice a day. A.M. Lyon was the town's first postmaster. Bill List, Naval Reservist of the Year in 1964 and a local Republican, was appointed by President Eisenhower in 1959 as postmaster and served until 1979. Early in the century, downtown Struthers had a train depot. Standing in front of it in the undated photograph below is an unidentified young man. (Left, courtesy Gregg Wormley.)

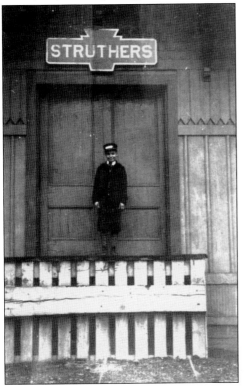

The Thomas Struthers Memorial Library first operated out of the Knights of Pythias building on South Bridge Street, pictured here, for 20 years. The new building at 95 Poland Avenue was dedicated as a branch of the Public Library of Youngstown and Mahoning County and was presented debt free to the community in September 1957. The facilities and holdings were equaled in only a few other communities of comparable size.

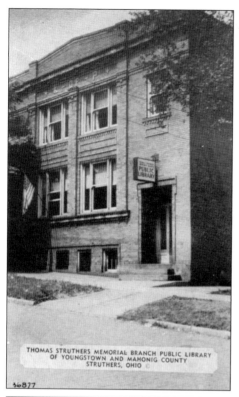

THOMAS STRUTHERS MEMORIAL BRANCH PUBLIC LIBRARY OF YOUNGSTOWN AND MAHONIG COUNTY STRUTHERS, OHIO

36877

Immigrants from many parts of Europe brought their traditions. Pirohy (filled dumplings), halushki (cabbage and noodles), pizza, spaghetti with meatballs, cannoli and tiramisu (Italian pastries), and puska (traditional Easter bread) are only a few of the foods. Another beloved tradition, most guests would agree, is the cookie table at wedding receptions. Social and political convictions, influenced by culture and customs, were also part of the fabric of everyday life. (Courtesy of Paula Ringos Drapcho.)

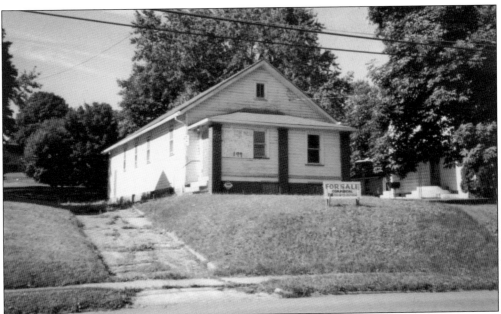

This is a 1998 photograph of the closed and shuttered Croatian Hall at 199 Lowellville Road. Formed in 1938, the American Croatian Political Club's charter stated that it was a political and social club promoting the study of political institutions and the science of government while providing a place where its members could enjoy the society of each other and their friends. (Courtesy of Marian Kutlesa.)

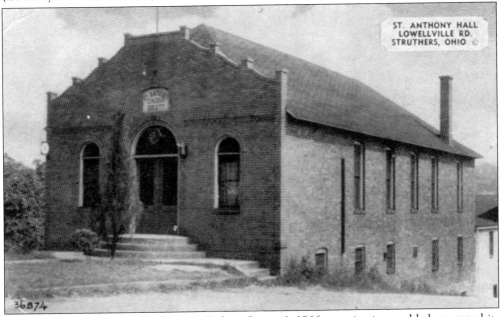

Founded in 1928, the St. Anthony DiPadova Society's 1966 constitution and bylaws stated its membership was for those who were "a native of Italy, or a descendant of Italian parents or parent, or the spouse of a person of Italian descent." The initiation fees were levied according to age, and membership at that time was limited to those between 18 and 39 years; 18–24 years of age was $5; 25–29 was $6.50; 30–34 was $8; and 35–39 was $10.

Neighborhoods developed according to economics, ethnicity, and other factors, including living closest to the gate of the steel mill where a person worked. These areas had names like Coke Alley, Pink Tea Hill, the North Side, Dog Patch, and Nebo. Of these, Nebo and the North Side have kept their identities strong, most likely because of geographic separation; Nebo lies alongside Yellow Creek and the North Side is across the Mahoning River. Nebo is the Slovakian word for heaven. Others say it is named after Mount Nebo, from where Moses viewed the promised land. The stately home on Center Street above is located just beyond where a Camp Nebo stood near Clingan Road. The camp had a cabin and held Boy Scout and Camp Fire Girl meetings. It eventually burned. (Above, courtesy of Debbie Zetts; left, courtesy of Frank Marr.)

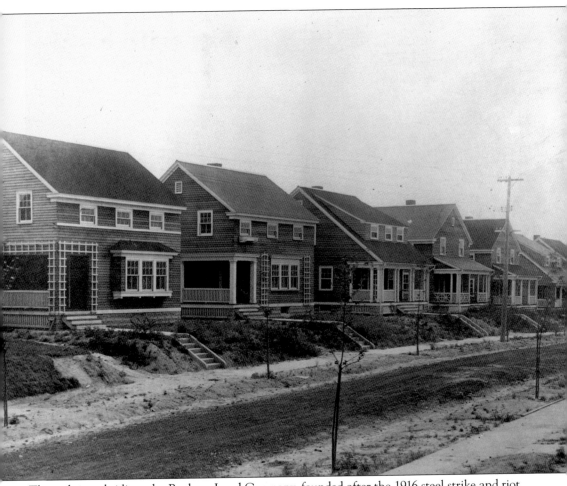

Through its subsidiary the Buckeye Land Company, founded after the 1916 steel strike and riot, the Youngstown Sheet & Tube Company sought to prevent unionization by providing housing opportunities for "good company men." The average cost of these houses was $3,000 to $5,000. According to Donna DeBlasio in *Youngstown*, the company designed three distinct plats: Blackburn in East Youngstown (Campbell), which had homes available for rent; Highview in Struthers for immigrants; and Loveland for white, American-born employees. A fourth for African-American employees was added later. In its first decade of operation, the Buckeye Land Company built more than 700 homes, selling 300 of them and renting the others. These neighborhoods provided a sense of community, with schools, churches, and a variety of social and athletic activities. The homes pictured here are located on the Creed Street part of the Highview plat.

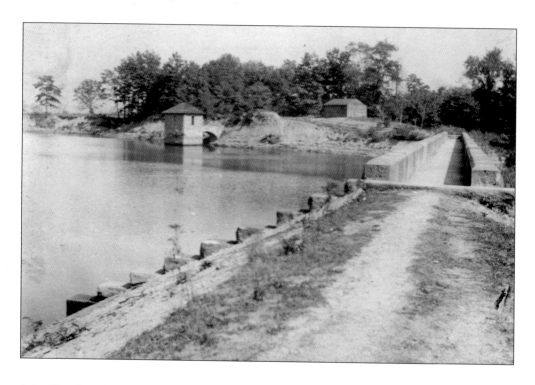

Lake Hamilton dam, built in 1907, was formed by ashler masonry and exists as one of the finest examples of stone work in the United States. It has a height of 70 feet and a thickness through the base of 45 feet, tapering to 10 feet at the top. It is 240 feet long with a six-foot walkway across its crest. It calls to mind the words of Mahatma Gandhi: "There is more to life than increasing its speed."

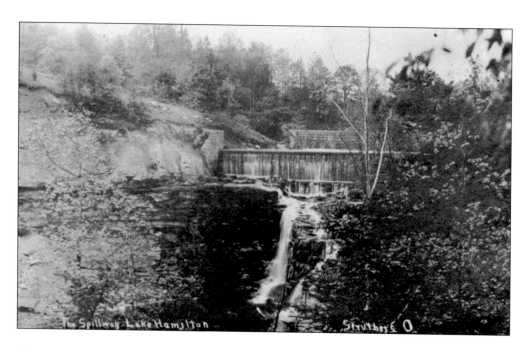

Three

PARKS, POOLS, AND PARADES

To be interested in the changing seasons . . . is a happier state
of mind than to be hopelessly in love with spring.

—George Santayana

Here, photographs attempt to capture
seasonal beauty, starting with the entrance
to Yellow Creek Park. This house was one
of the oldest in Struthers. It was known
as the McKinney home, Shady Oaks, and
the Sontich home, and finally served as
the park office before it was demolished
in 2008. (Courtesy of Dan Mamula.)

Another Yellow Creek Park entrance and parking lot is on Wetmore Drive. The 76-acre park was described in 1920 by Joseph Butler in *History of Youngstown and the Mahoning Valley Ohio*: "the valley, or gorge, is of various widths, the hillsides steep and covered with evergreens, the fall of water in the creek abundant and resembling a rushing mountain stream rather than a Midwest waterway." From its source, the creek flows due north into the Mahoning River, draining a watershed of about 46 square miles. (Courtesy of Dan Mamula.)

In the park is the Capt. John Struthers Pavilion. It is said that Struthers, a Revolutionary War veteran from Pennsylvania, chased a raiding band of Indians in 1798 through this valley, later coming back to settle with his family. He built the family log cabin on a knoll overlooking Yellow Creek. (Courtesy of Mill Creek Parks.)

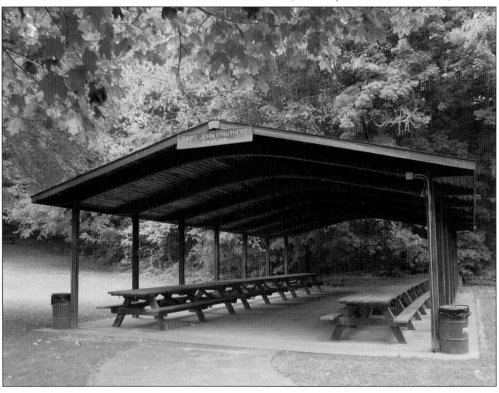

Hiking, swinging, sliding, tennis, basketball, and picnicking are some of the activities that draw visitors. Ice-skating was also permitted in the past, and the caretaker would build a large fire for warmth. Parents felt their children were safe because if they fell through the ice, it was only knee-deep. Fall colors are muted in this black-and-white photograph. (Courtesy of Mill Creek Parks.)

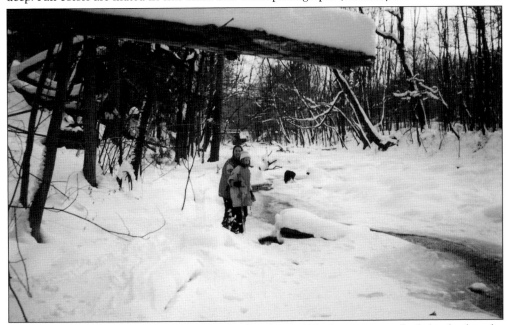

First recorded on county maps as a designated park in 1895, the city never had the deed to the property until 1940, when city solicitor Theodore Macejko obtained it from Edward D. Wetmore of Warren, Pennsylvania, who, as the sole trustee of the Thomas Struthers estate, donated the land. Struthers then owned the park. In 1995, Stacie (left) and Kimberly Beach enjoy a winter hike along the creek trail. (Courtesy of Paul Ringos.)

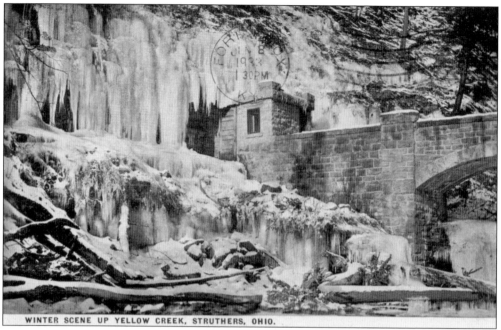

WINTER SCENE UP YELLOW CREEK, STRUTHERS, OHIO.

Winters can be harsh in northeastern Ohio, but spectacular in Yellow Creek. This 1933 postcard is only one example. The photograph below, taken in 2010, is no less beautiful. Many improvements to the park were made with the assistance of the Works Progress Administration (WPA), whose crews created trails and retaining walls. The WPA was the largest New Deal program/agency and operated by presidential order between 1935 and 1943, providing jobs and income to millions of people across the nation during the Great Depression. On May 25, 1991, the park officially reopened under Mill Creek Metropolitan Park District. (Above, courtesy of Betty Kossick; below, courtesy of Dan Mamula.)

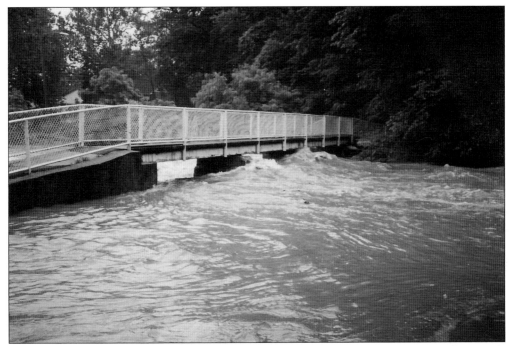

Springtime thaws can produce flooding, as seen here. One of the biggest overflows in Yellow Creek occurred in 1990. That year, high waters roared on their way to the Mahoning River, carrying debris and sediment and spilling over the banks in many places.

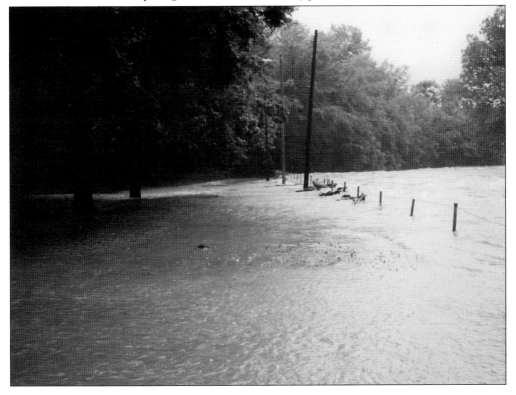

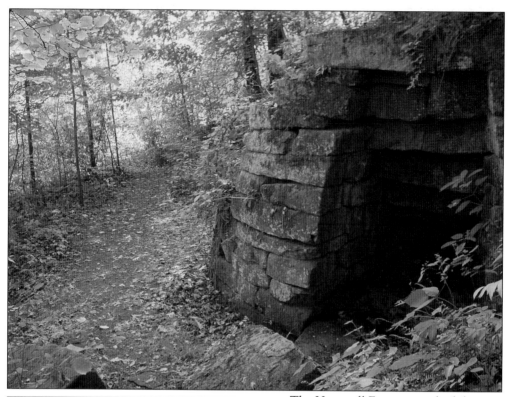

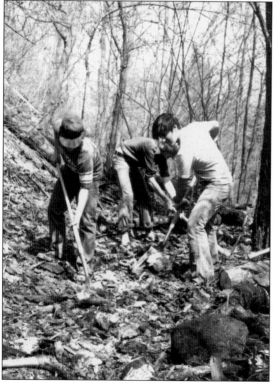

The Hopewell Furnace was built by the Heaton brothers early in the 19th century and is cited as the beginning of the steel industry west of the Allegheny Mountains. Uncovered through the Struthers Total Environmental Education Program (STEEP) in 1975, it is located within Yellow Creek Park and has a historic designation. STEEP, administered by Struthers High School faculty Daniel Mamula and Dominick Russo, offered a field-study environmental course for which the students received credit. Dr. John White, assistant professor of sociology and anthropology at Youngstown State University, directed the extensive excavation. Other Struthers teachers involved were Vito Carchedi, Mary Ann Fimognari, Janice Guy, George Lancaster, and Robert Simerlink. About 25 students were involved. Some, like Pat Bundy working in the background at left, worked well beyond their course credit time. (Above, courtesy of Mill Creek Parks.)

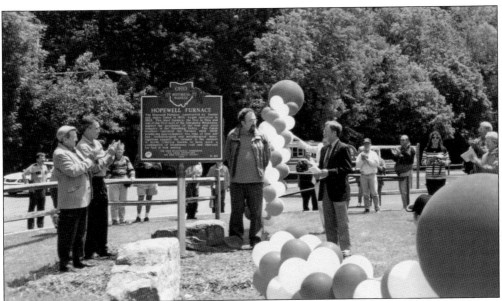

The Hopewell Furnace Memorial on the shores of Lake Hamilton was dedicated July 5, 1976, almost 170 years after the furnace was built. The memorial is about a quarter mile from the original furnace site. Pictured during the ceremony are, from left to right, Russo, Mamula, and Dr. White. The memorial reads, "To all those who pioneered and developed the steel industry in the Mahoning Valley. It represents the farsightedness of industrialists, the technical skills of engineers, the 'know-how' of mill operators, and the workmanship of labor. Through their cooperative efforts, steel has provided the means for growth and prosperity in this 'steel valley' community for many of our nation's 200 years." Within the ingot lies a time capsule filled with gifts from 1976 residents to those of 2076, messages to a time and place they will never see. (Above, courtesy of Dan Mamula.)

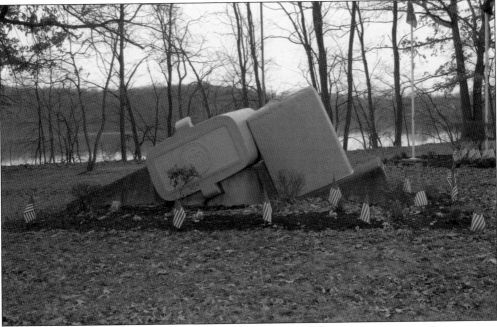

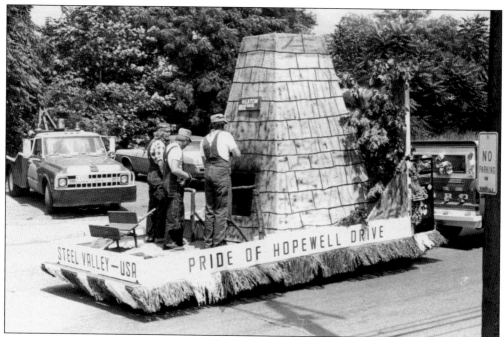

The US Bicentennial in 1976 was an event in Struthers. It kicked off with a parade on July 4, 1975, beginning at the Fifth Street Plaza, winding through the city and ending at Mauthe Park. Throughout the yearlong celebration, other festivities included the Presidential Ball, the Bicentennial Boogie for Struthers High School students, a hoedown, and an ecumenical service. It culminated with a picnic and a cultural ethnic day variety show, square dance, bonfire, and community sing on July 4, 1976. This celebration is nicely documented in *Struthers, Ohio Cradle of Steel: Bicentennial Commemorative Book*. Below, chairperson Gerald Schonhut, with picnic chairpersons Sharyn Kennedy and Pat Floryjanski, starts the festivities. The winning float above commemorates the Hopewell Furnace.

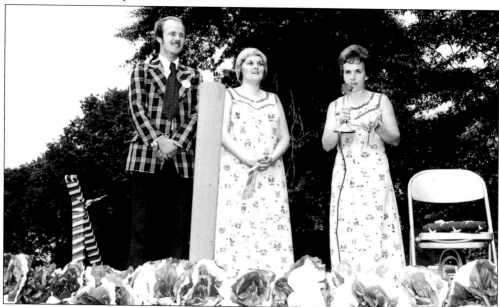

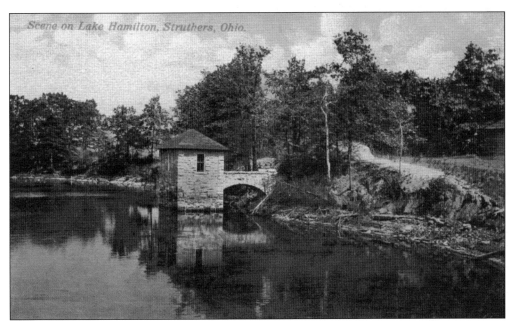
Scene on Lake Hamilton, Struthers, Ohio.

As part of his class work at Youngstown State University, Allan "Chuck" Mastran was responsible for the successful nomination of Hamilton Dam, the gatehouse, the spillway, and the aqueduct to the Ohio State Historical Advisory Board for listing in the National Register of Historic Places in 1984. The gatehouse is pictured above in 1913. This picture of tranquility hides the lake's origins as a basin blasted to confine the waters of Yellow Creek in 1907. It covers about 101 acres and has a storage capacity of 800 million gallons. When water levels fall, one or two islands appear. In the early years, boating, fishing, and picnicking were popular activities. (Below, courtesy of Dan Mamula.)

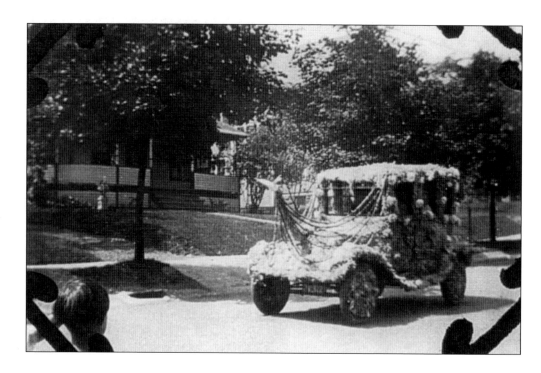

Here are some very early Struthers parade pictures. The 1920 photograph above shows the prize float, but it is unknown what the occasion was. The 1948 Cradle of Steel Parade below marches down State Street celebrating work and heritage.

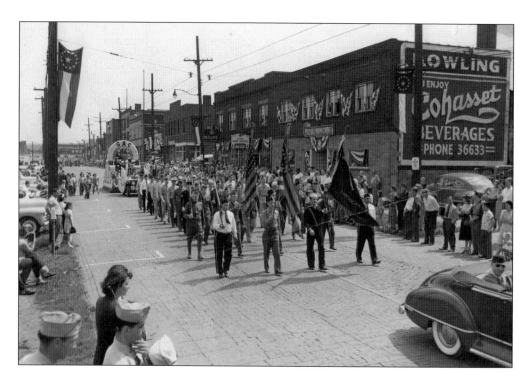

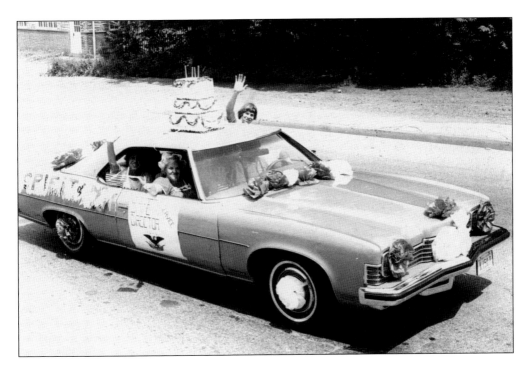

The Fourth of July Parades, pictured above in 1975 and below in 1990, featured cars and floats. This parade continues to be a big event. According to head coordinator John Medvec, the 2014 Fourth of July Parade had more than 128 units participating and 5,000 people watching. Marian Kutlesa served as the grand marshal that year, leading the festivities with her daughter and great-granddaughter. The 1990 float below is the work of St. Nicholas Church.

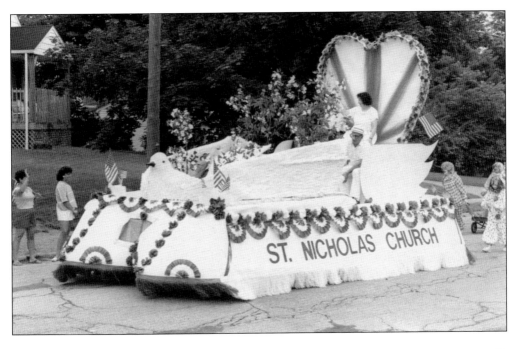

Located on Wetmore Drive, "the birdbath," a circular pool with a maximum depth of nine feet, was built in 1939 for $60,000 and operated for 40 years. It had an island with a diving tower of two high boards and two lower boards. A unique feature was its underwater observation room providing an added safety feature. A six-day attendance record of 5,299 people was set June 7–12, 1959. Below is George Washington Flickinger, on the right in suspenders, during pool construction. The pool was built with Public Works Administration (PWA) funding. PWA, separate from the WPA mentioned earlier in this chapter, was part of the New Deal with funding for large-scale public works projects in response to the Depression. The banister behind the men was the distinctive entrance to the pool from the changing areas up above on the second floor, with steps down to the pool on either side. (Below, courtesy of Carol Gillen.)

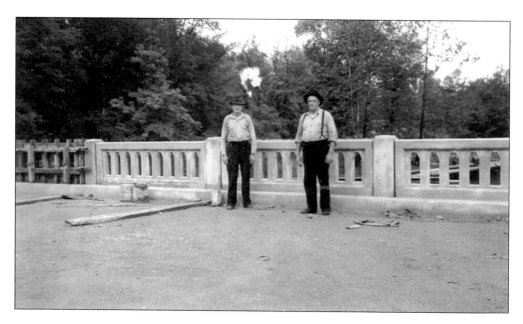

The Red Cross offered swimming lessons at the pool. Many remember those cool mornings, with even colder water temperatures, learning to put heads under water, float, swim, and dive. Then, no matter which direction from the pool youngsters lived, they would sweat climbing the steep hills that had to be negotiated walking home on a hot afternoon. High school groups often operated concessions close to the pool's front entrance as fundraisers. The pool site is now overtaken by nature but is pictured below in 1947 with the familiar surrounding chain-link fence. There are many stories of how this fence did not keep swimmers out who were brave and agile enough to climb it after dark on a hot summer night. Sitting in the sand, which the pool had for a time, are Caryl Schwab (left) and Betty Kossick. (Both, courtesy of Betty Kossick.)

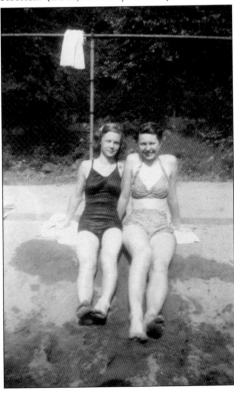

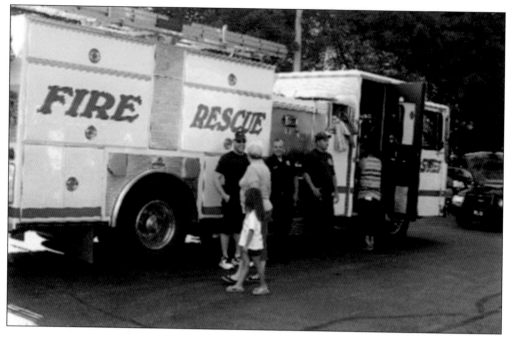

Another big party is the Struthers Day celebration, which began in 1998. Sponsored by Aqua Ohio Inc. and held at Mauthe Park, the celebration includes free food and beverages, like hot dogs, popcorn, watermelon, and snow cones; live music; good times; and a sense of community. These pictures are from 2014. Standing in front of the fire engine are, second from left, police officer Jason Murzda (K-9 unit officer) and fire department engineer Brian Halquist. The young man below is unidentified. (Both, courtesy of Pat Bundy.)

On Memorial Day in 1960, Mauthe Park had a dedication ceremony. It was previously known as Smithfield Park Playground. About 1,000 people attended to watch and participate in the program, which included a parade, speeches, and six two-inning ball games. J.L. Mauthe, chairman of the Board of Youngstown Iron Sheet and Tube Company, was honored for his work in developing the park and supporting area youth. Mayor Milligan dedicated the field to "the city's taxpayers and youth." Below is a later aerial view of the park, which has a shelter house, playground, and ball fields. It continues to host tournaments and summer concerts. (Below, courtesy of Dan Mamula.)

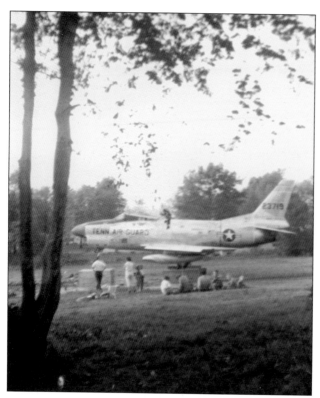

In Mauthe Park sat a fighter jet from the Korean War given to the city by the Air Force and dedicated to Cyril Bolash and other Struthers airmen who gave their lives for their country. Bolash, 21 years old, was a World War II gunner shot down and killed over Austria in 1944. Bolash had once written in a letter home, "The way I see it, life is a lottery and God himself is drawing the numbers." When he turned down a chance to be an instructor, he said, "I make no claims to bravery, but I'd rather get the enemy in my gun sights than train somebody else to do it for me. I consider myself a pretty good gunner and I feel I can do more for my country out there." The Korean War jet was eventually torn apart. (Below, courtesy of Nancy Johngrass.)

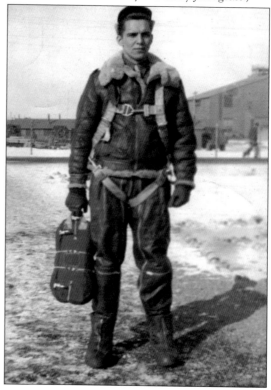

Four

PROTECTING

*A nation reveals itself not only by the men it produces but also
by the men it honors, the men it remembers.*

—Pres. John F. Kennedy

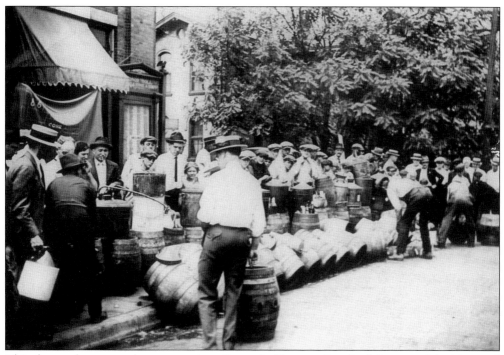

This chapter focuses on the preservation efforts of military, police, firefighters, and the historical society. In 1919, Congress passed the 18th Amendment making the manufacture, sale, or transport of intoxicating liquors illegal. During Prohibition, Struthers had a strong reputation for prosecuting offenders. Here, agents dump seized liquor in front of city hall.

The Veterans' Memorial sits on the grounds of the high school. Once only a stone dedicated in 1952 to honor those who fought in World War II, it was expanded by local volunteers in 2006 and is now surrounded by six stone tablets with the official seal of each branch of the military. The final refurbished monument honors all veterans who served in the military with names on a brick walkway. According to Chairman Gene Yuhas, work took six years at an estimated cost of $75,000, with about $40,000 in donated labor. Significant support was provided by Struthers graduates Tony Lariccia and Sandy DiBacco. Dr. DiBacco also served as superintendent of Struthers schools. Pat Bundy, Denise Collingwood, Richard Dale, Gary Mudryk, and Mike Goskie are also working to preserve the memory of those from Struthers who died in all military conflicts through the Struthers Fallen Soldier Project. (Both, courtesy of Paul Ringos.)

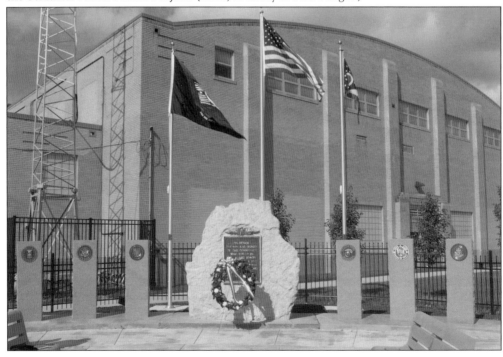

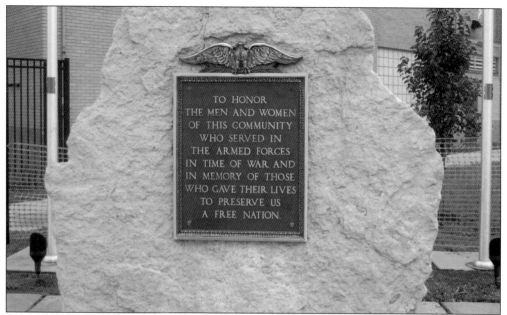

Struthers men and women have served in all branches of the military. Some lost their lives serving. After World War II, the return of military to their homes was marked by parades across the country. Struthers was no different. These pictures show the welcome the community gave to their sons and daughters and reflect remembrance for those who did not return. In respect and gratitude, names of those who lost their lives are recorded in this chapter. The following Struthers men died in World War I: Joseph Byers, James Dicicco, Fred Groner, Earl Higley, James Jackson, Stephen Pidick, Andrew Sekerak, and John Stroup.

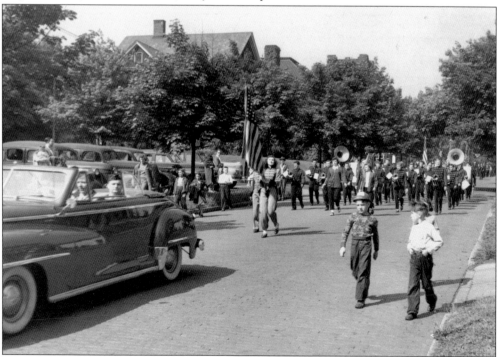

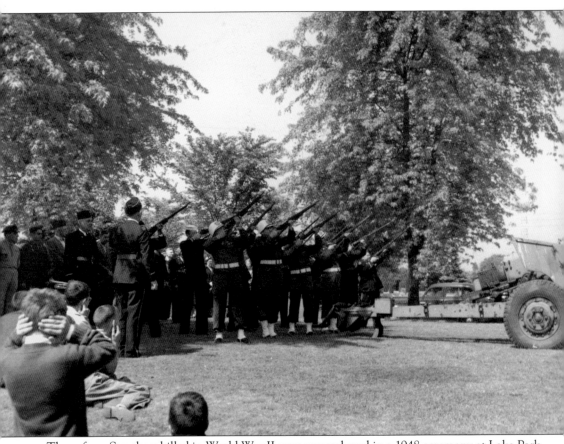

Those from Struthers killed in World War II were remembered in a 1948 ceremony at Lake Park Cemetery, just outside of Struthers on Midlothian Boulevard. The following men perished during World War II: Robert Bates, Joseph Bestic, Cyril Bolash, Victor Boyer, Walter Bunetta, John Canyo, Leo Carney, Francis Conner, Chester Del Signore, John Dindinger, Steve Domladovac Jr., George Dutko, Carl Dutton, Mike Fabian, Charles Franko, Michael Goskie, Francis Hallas, Thomas Hannis, Frank Harnutovsky, Daniel Harrington Jr., Robert Henderson, Gerald Himes, Carl Hiner, James Jones Jr., John Kiktavi, John Koly, Stephen Kozusko, Robert La Paze, Barnet Levy, James Lind, Alfred Magazzine, Donald McAllister, James McClure, Hugh McQuade, Peter Mignella, Frank Ondrey, Nettuno Ortali, Thomas Pruse, Thomas Pugh, Vincent Raney, George Resetar, Clark Schoonover, Rudy Seaberg, Martin Sedlak, Joseph Shevetz, Howard Sipe, Thomas Templeton, John Thompson, James Turnbull, James Watt, Henry Williams, Francis Wilson, and Ernest Yauman.

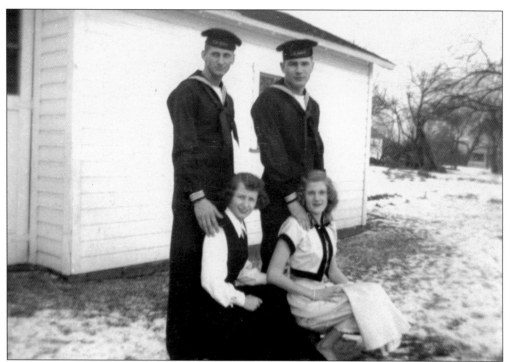

Men and women left loved ones to join the military. Some, like Paul Ringos and Rose Banozic (left), were separated for months and years when he was immediately deployed to the Philippines after boot camp, postponing their planned 1950 wedding until 1952. Others, like Edward Marsh and Lillian Vlosich (right), were able to marry and move together stateside after their wedding. (Courtesy of Ed Marsh.)

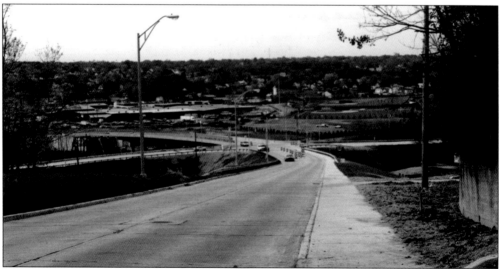

Dedicated October 6, 2000, the Korean Veterans Memorial Bridge carries State Route 616 over the Mahoning River. Locals killed in the Korean War were Edward Paul Johnston, Edward Ontko, John Phillips, Byron Pittman, and Clarence Stricklin Jr. Killed in the Vietnam War were Ronald Charles, Leonard Hauserman, Walter Hoxworth, Charles Huzicko, John Mirich, Eugene Paliskis, and Jerry Rogers. (Courtesy of Marian Kutlesa.)

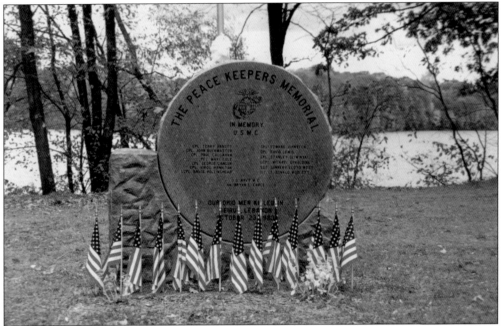

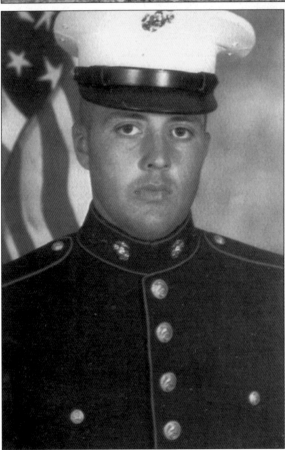

On October 23, 1983, 241 Marines, sailors, and soldiers deployed on a peacekeeping mission in Beirut, Lebanon, died in their sleep when a truck loaded with 2,000 pounds of dynamite crashed through the gates of their barracks. This Peace Keepers Memorial, built on the shores of Hamilton Lake, commemorates the 14 Ohioans who lost their lives in that bombing. One Struthers man, 22-year-old Edward A. Johnston, was killed. Besides his parents, Edwin and Mary Ann Johnston, who were instrumental in bringing this memorial to Struthers, Eddie left behind a young wife, Mary Lynn (West), and a two-year-old daughter, Alicia. The memorial was dedicated to "our Ohio men" on October 22, 1989. (Above, courtesy of Dan Mamula; left, courtesy of Pat Bundy.)

This 1990 Struthers Police Reserve Auxiliary picture includes the first female police officers: C. Lawn, Dorothy McLaughlin, and Myra L. Reddinger. Joining as auxiliary members in 1966, they served without compensation, assisting the local police in emergencies. Reddinger was the first woman to graduate from the Mahoning County Police Officer School in 1965 and served in Struthers for 32 years, being promoted to sergeant in 1983. (Courtesy of Freeze Photography.)

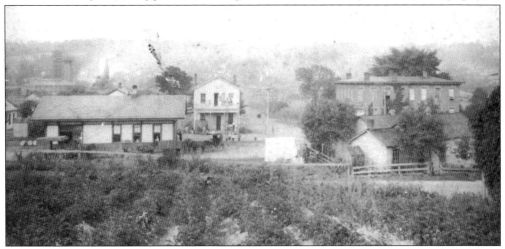

Generally a peaceful community, Struthers has had some notable and tragic crimes in its history. Two burglars, Rufus Gates and Tom Cummings, were remembered for their capture rather than their crime. In 1899, after robbing the Pittsburgh and Lake Erie depot of tickets and money, they were pursued by a train crew in a locomotive. While the thieves were on foot, they were caught near Lowellville and taken to the city jail. The depot is pictured on the left.

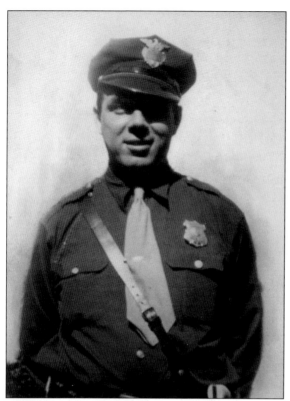

Patrolman Raymond Darwich (1923–1952) was directing traffic at the scene of a two-car accident on Youngstown-Poland Road and Weston Street when he was struck and killed by a car driven by John Jones. Darwich was thrown 62 feet, causing multiple injuries. He had been appointed to the force earlier that year by Mayor Milligan, who eulogized: "life [was] taken away while serving the public. Ray was an honest, likeable, intelligent and willing officer. The loss of his life will be great, not only to his wife and two small daughters, but to our community." (Courtesy of Frank Marr.)

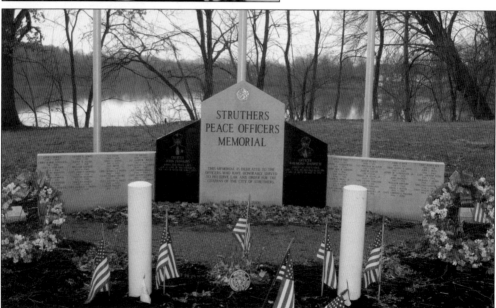

At the edge of Lake Hamilton stands the Struthers Peace Officers Memorial. It is a tribute not only to the two officers killed in the line of duty, but to all who served honorably as police and reserve officers. Also recognized is a Pennsylvania state trooper killed in Struthers in 1918 serving a murder warrant, and a Struthers officer who died of a heart attack while on duty. Capt. Pat Bundy spearheaded the work, and the Fraternal Order of Police gave $20,000 for its construction.

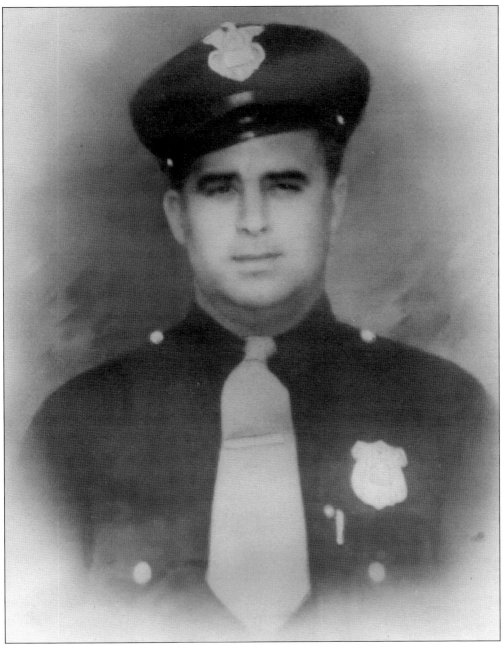

Patrolman John Harkins (1916–1952) and partner Richard "Doc" Quinn were making routine checks in 1952 when they discovered a break-in at McIntee Motors. While Quinn struggled with burglar William Corey, Harkins moved to check the restroom. Kicking in the door, he found John Corey, who fired four shots, hitting Harkins twice in the chest and once in the abdomen, killing him. Both men were convicted of first-degree murder and sentenced to life in prison. Harkins's wife, Grace, said, "He loved being a cop and I feel this would be the way he would want to go, serving people." Harkins also had two young daughters, Patricia (age 10) and Kathy (age 4). Only hours before the shooting, Harkins had baked a cake to celebrate his wife's 34th birthday before leaving to work his 11:00 p.m. to 7:00 a.m. shift.

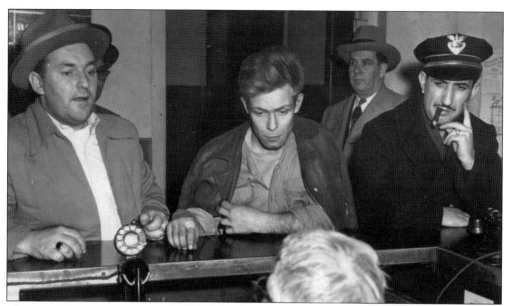

The community responded strongly with support that included fund drives to pay off the Harkinses' $6,000 mortgage. In 1952, a patrolman made $234 a month, and a widow received $2,500 in life insurance and a $120 a month pension. Pictured above is the booking of John Corey at the police station. Corey is in the middle, and Officer Nick Polito is on the right. The solemnity of Harkins's funeral with the flag-draped coffin is seen below, as the procession prepares to leave Davidson Becker Funeral Home. (Both, courtesy of Gregg Wormley.)

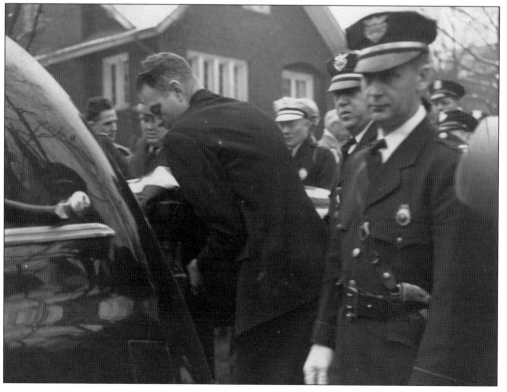

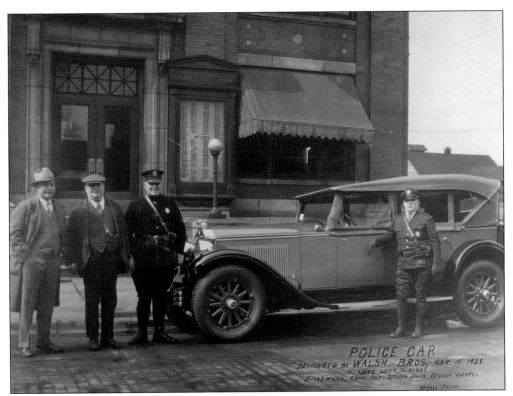

POLICE CAR
DELIVERED BY WALSH BROS. MAR. 16. 1928.
READING LEFT TO RIGHT
Bobby Walsh, Chief Rex, Officer Davis, Officer Harvey.
SCHALL PHOTO.

In 1928, Walsh Brothers delivered a new police car. From left to right are Bobby Walsh, Chief Rex, and Officers Davis and Harvey. This was the era when the first of three generations of Sickafuse family officers began service in the Struthers Police Department. First, George Washington Sickafuse (1874–1932) was appointed in 1911 by Mayor Stough and was promoted to chief of police in 1931 by Mayor Roberts. (Above, courtesy of Schall Photography; right, courtesy of Frank Marr.)

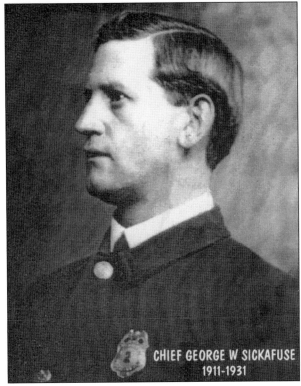

CHIEF GEORGE W SICKAFUSE
1911-1931

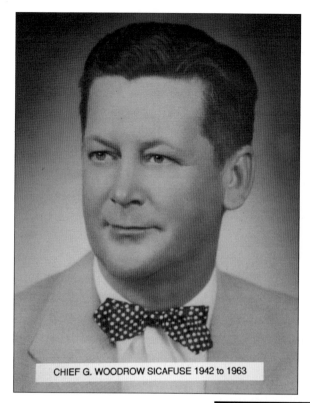

CHIEF G. WOODROW SICAFUSE 1942 to 1963

G. Woodrow Sicafuse (1913–1963) was appointed in 1942 by Mayor Strain and was promoted to chief in 1953 by Mayor Milligan. (Note the spelling change in the surname; the family had dropped the "k.") Donald D. Sicafuse was appointed in 1964 by Mayor Papalia and was promoted to captain in 1976 by Mayor Centofanti. (Both, courtesy of Frank Marr.)

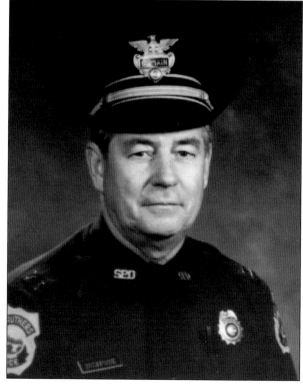

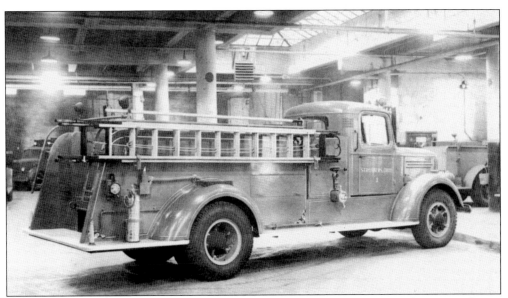

Michael Patrick has protected the community and its history as a city councilman, as a former volunteer firefighter for 27 years, and as the current owner of the 1943 Mack fire truck used by the city for almost 40 years. Dick Dale and Don Clemente, former members of the fire department, were responsible for getting the truck back to Struthers when the collector who owned it in Columbus, Indiana, died. The collector's survivors had contacted the Struthers Fire Department wanting to know if any members were interested in returning the truck to Struthers. It was bought for $1,170 and came back on a flatbed truck. The vehicle was restored, and Patrick eventually bought it from Clemente. Today, it is used in parades and even some funerals. (Both, courtesy of Michael Patrick.)

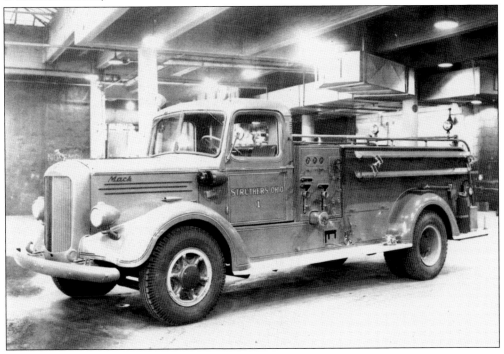

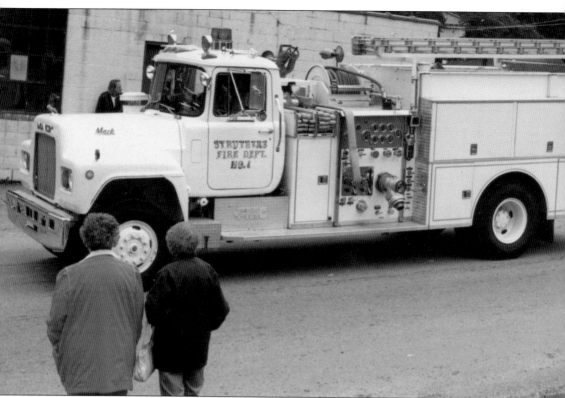

The fire department, funded by the first Struthers tax levy, was started in 1903 after significant fires in 1901 and 1903 caused injuries and property losses. Over the years, the department has been a careful steward of the engines. In 1971, the department's 1943 Mack engine would not start reliably, and a new red truck with white interior was ordered from an Indiana company. Upon receiving the engine, it was obvious the order was reversed; it was a white engine with a red interior. Chief Cooper decided that it was badly needed, and rather than waiting for the truck to be repainted, the department accepted the white one. Today, all Struthers fire vehicles are white with red interiors.

Before 911 emergency numbers, communities still needed a notification system. Fire alarm boxes mounted on poles were part of the city's emergency alert system. For a citizen to sound a fire alert, the 1949 *Fire Manual* instructed, "First, break the glass in little door, turn key and open door. Second, pull down the hook once and let go, and stay at box until the department arrives and give them the location of the fire." The number of loud piercing rings would give the location of the fire alarm box that was activated closest to the fire. For example, 1-2, or one ring then two more rings, was Bridge and Broad Streets; 5-3, five rings and three more rings, was Midlothian Boulevard. This system covered the city. The still functional police box shown here was a call-in system but also sounded a loud alarm. It is part of the Struthers Historical Society's collection. (Both, courtesy of Frank Marr.)

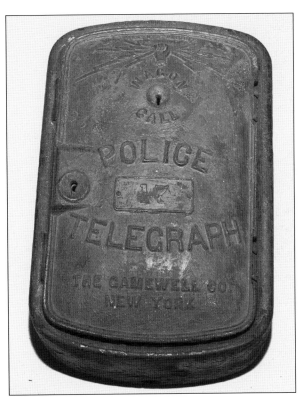

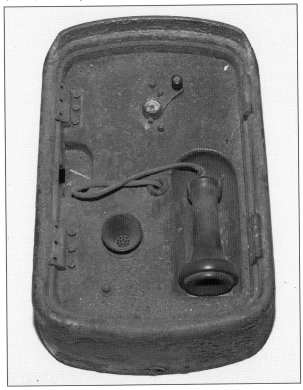

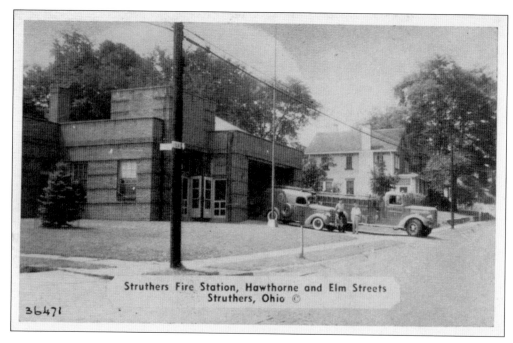

Struthers Fire Station, Hawthorne and Elm Streets
Struthers, Ohio ©

36471

The fire department was relocated to several buildings during its first few years; one relocation was to the abandoned United Presbyterian Church. When the church moved to a new stone structure, the city relocated the fire department to the old wooden church on Yellow Creek hillside. The first permanent location was established in 1943 at the present station at 96 Elm Street (above). In 1953, the North Side Building (below) was added. (Below, courtesy of Frank Marr.)

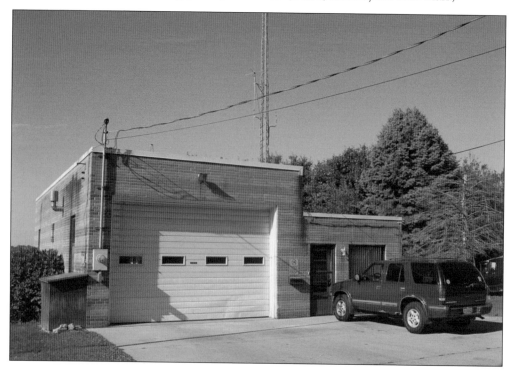

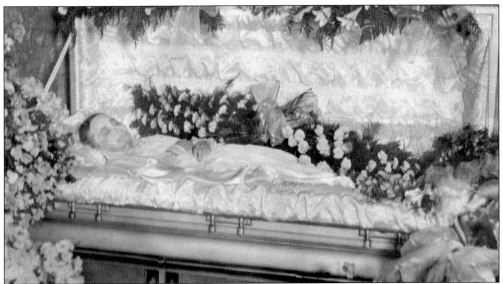

The Struthers Historical Society began as an effort by Marian Kutlesa to preserve the stories and memorabilia that had been collected for the country's bicentennial celebration in 1976. Financially supported by gifts from individuals and the Struthers Rotary, the group later acquired its home on Terrace Street after using members' homes, the library, and space at Highland School for storage. The 1921 photograph above shows Louisa Frankfort's wake in the home's living room, a common practice at that time. She and her husband, Alexander, Struthers's last surviving Civil War veteran, had bought the property in 1884. Four of their eight children were born in Struthers, including Alma. Alma resided in the home her entire life, having been married only about one month to George Strain before their divorce. Alma's heirs, Howard Mohr, Daniel Mohr, Marijane Wagner Clayman, and William Wagner, gave the keys to the home to the society's president, Bill Andrews, in 1986.

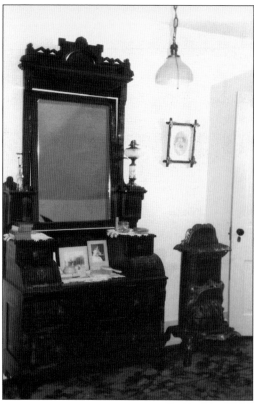

Renovation work was completed as a labor of love by volunteers and is seen in these 1992 photographs. Furniture, antiques, military and steel mill displays, and other artifacts fill the home. An angled chimney in the center of the house is a unique heating design. Narrow stairs lead up to a library with a collection of high school yearbooks, city directories, files of individual pictures, and *Journal* newspapers. Rugs and colorful clothing from bygone eras are preserved there. Looking through this collection is a reminder that, in the words of Jeremy Irons, "we all have our time machines. Some take us back, they're called memories. Some take us forward, they're called dreams."

Five

PROVIDING

Someone's sitting in the shade today because someone planted a tree a long time ago.
—Warren Buffett

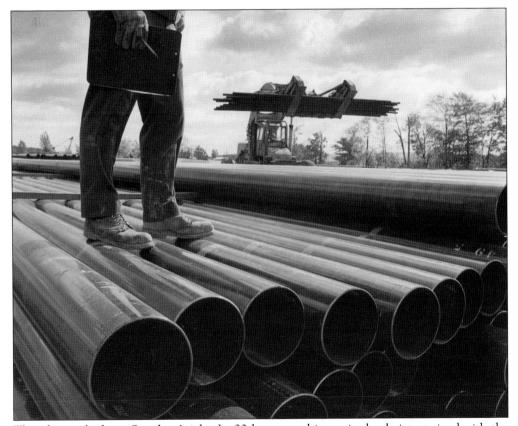

This chapter looks at Struthers's jobs. Its 20th-century history is closely intertwined with the making of steel. Seen here is steel pipe being loaded on a truck in Panther Run. (Courtesy of Ohio History Connection.)

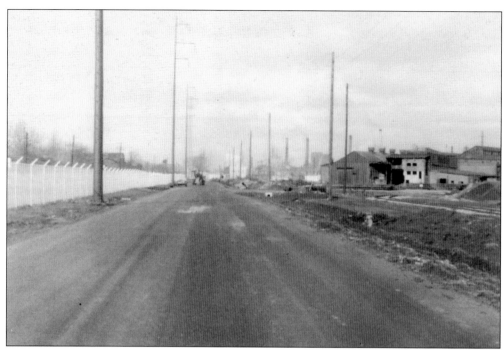

Growing up, many children may have thought or been told, as Frank Marr was, that the white steam from the coke processing plant was "where God makes clouds." But the steel industry was not heavenly. It was hard work. These two pictures, taken roughly 30 years apart, show the changes along the river, looking west towards State Route 616. In 1982 (above), the steel mill buildings with their smokestacks remain evident, but just over three decades later, in 2013, this stretch was transformed into a grassy, tree-lined industrial park. (Both, courtesy of Frank Marr.)

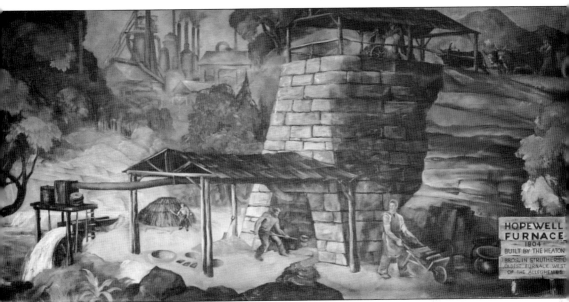

The steel industry in Struthers can be traced back to the Hopewell Furnace. In 1802 or 1803, brothers Daniel and James Heaton built the furnace on the west side of Yellow Creek about one and a quarter miles from the Mahoning River and 500 feet north of the dam now forming Lake Hamilton. This first furnace west of the Allegheny Mountains was profitable because of the area's natural resources of iron ore, limestone deposits, timber, and the stream of water that provided energy for the blast, producing a hot fire in the furnace. These were the ingredients needed to make iron. At peak operation, it required nearly an acre of timber for charring each day. Trouble securing timber, furnace repair problems, and the War of 1812 forced operations to close. This painting, relocated from its previous home in the high school and on loan from the Struthers Historical Society, now hangs in city hall. (Courtesy of Frank Marr.)

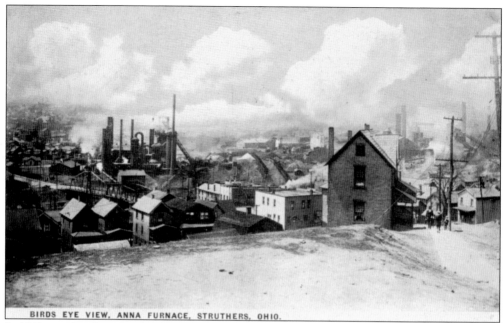

BIRDS EYE VIEW, ANNA FURNACE, STRUTHERS, OHIO.

In 1869, another furnace, the next-generation Anna Furnace, was built by the Struthers Furnace Company. Named after Thomas Struthers's daughter Anna, this blast furnace used bituminous coal mined near Nebo and around Fifth Street where Manor Avenue School would later be built. Anna last functioned in 1953 and was demolished in 1966. Product from this furnace supplied troops during the Spanish-American War, Mexican War, World War I, and World War II.

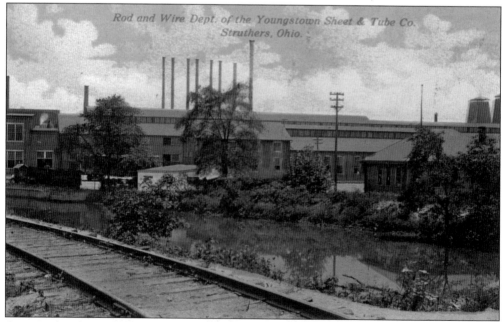

Rod and Wire Dept. of the Youngstown Sheet & Tube Co. Struthers, Ohio.

Organized at the dawn of the 20th century, the Youngstown Iron Sheet and Tube Company was later known as the Youngstown Sheet & Tube Company. On November 21, 1900, with authorized capital of $600,000, 55 investors signed to build and operate a mill for the production of iron sheets and tubes.

86

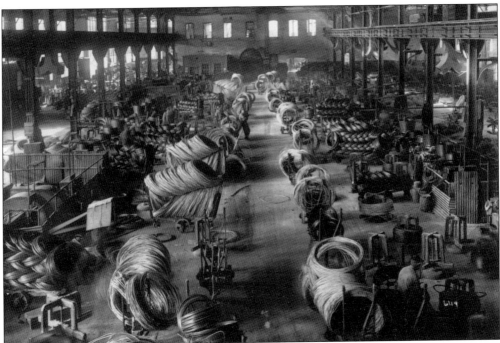

After World War II, an increased demand for automobiles, appliances, and defense needs during the Cold War fueled the steel industry. It was hard, dirty, and often dangerous work on a scale so large it defies imagination. But the money flowing through the local economy was appreciated on payday at the mills. Whether at the bank, the grocery store, or the local taverns, the good times were good. These pictures show glimpses inside the Struthers Rod and Wire Plant. Below in 1941 or 1942, Mike Loyboy and Bill Booher are at work. (Above, courtesy of Ohio History Connection.)

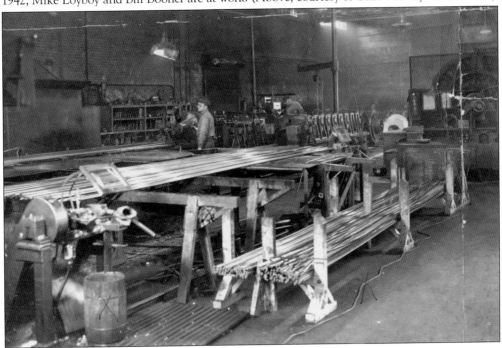

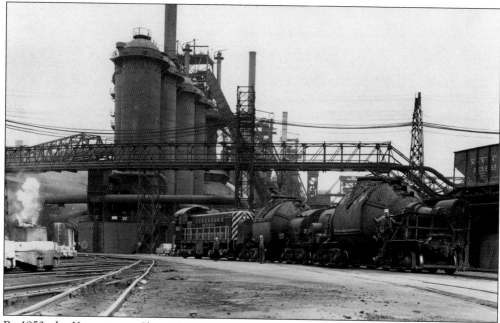

By 1950, the Youngstown Sheet & Tube Company operated plants throughout the Mahoning Valley and in 18 other states. It was a large employer of Struthers residents and throughout the Mahoning Valley. Above, bottle cars transport molten iron from blast furnaces. Lined with heat resistant brick, the bottle cars kept the iron hot for use in the open-hearth shop where it was processed into steel. The 1940 photograph below of the electric weld mill shows Jack Bieterman, Bob Toth, Paul Rivalsky, Stanley Telego, and John Adams reaming or enlarging the openings after steel pieces have been cut to length. (Above, courtesy of Ohio History Connection.)

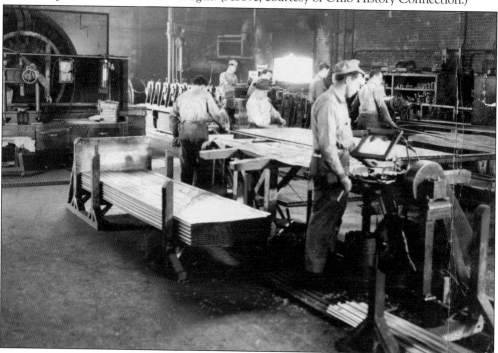

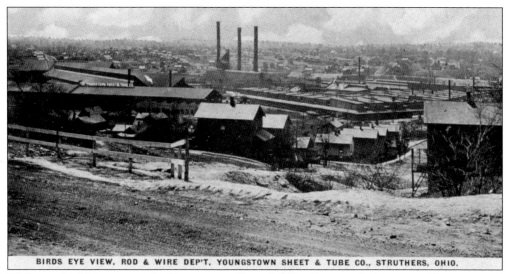

BIRDS EYE VIEW, ROD & WIRE DEP'T. YOUNGSTOWN SHEET & TUBE CO., STRUTHERS, OHIO.

Well into the 20th century, the Youngstown Sheet & Tube Company's European offices recruited immigrants from Southern and Eastern Europe to work in Struthers. There are many printed examples of companies posting notices in several languages to communicate with their multinational workforce. Italians, Slovaks, and Croatians were dominant groups that settled in Struthers. Many had to learn to speak and read English.

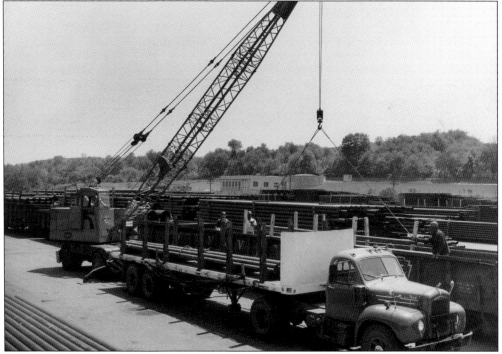

In 1976, approximately 970 Struthers residents worked for the Youngstown Sheet & Tube Company. When work was available, this labor force had a substantial paycheck, paid annual vacations from one to thirteen weeks, medical coverage, life insurance, a retirement plan, and a survivor's benefit plan. Shown here are pipes being loaded at Panther Run. (Courtesy of Ohio History Connection.)

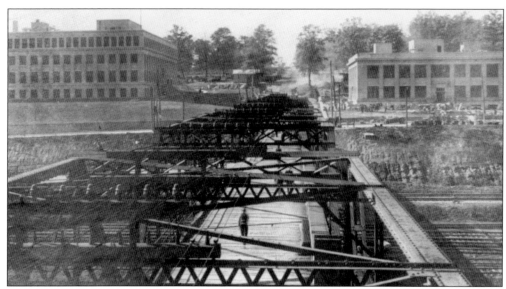

Stop No. 14 was the entrance to the mill at Walton Street. These four pictures taken together seem like time-lapse photography. Above is the building of the bridge over the river and railroad tracks with office and laboratory buildings in the back and horses parked in front of the buildings on the right. The picture below, taken in 1937 at the end of a mill strike, shows hundreds of workers returning to work. The volume of men and women employed was significant for the entire region. September 19, 1977, "Black Monday," was the day the Youngstown Sheet & Tube Company announced it was closing down its mills in Youngstown.

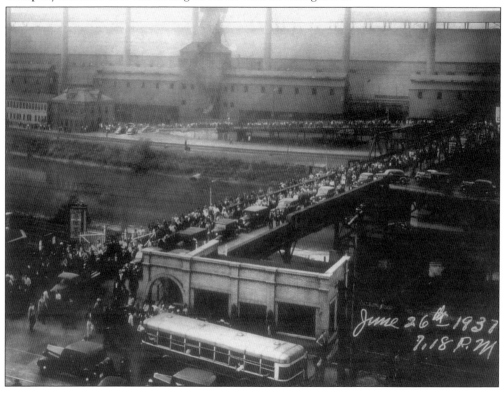

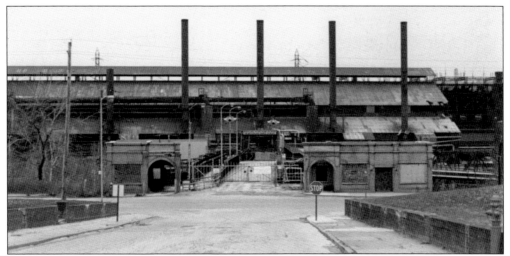

The official closing statement read, "Youngstown Sheet & Tube Company, a subsidiary of Lykes Corporation, announced today that it is implementing steps immediately to concentrate a major portion of its steel production at the Indiana Harbor Works near Chicago . . . The Company now employs 22,000 people. The production cut-back at the Campbell Works will require the lay-off or termination of approximately 5,000 employees in the Youngstown area." Pictured above is the entrance with guardhouses in 1977. Later, after all the closings, the Steelworkers Bridge, shown below, built and dedicated in 2005 at a cost of $3.8 million, honors the thousands of men and women who helped build the valley, bringing together the legacy of steel production with the future vision of a mixed-industry corridor. (Below, courtesy of Frank Marr.)

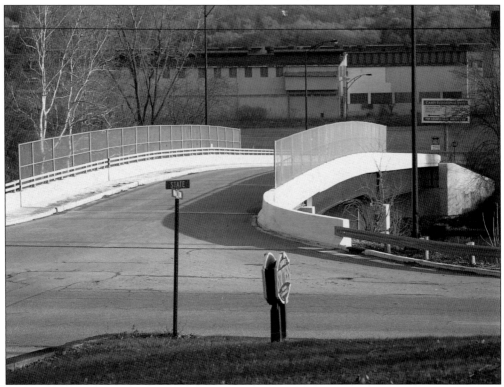

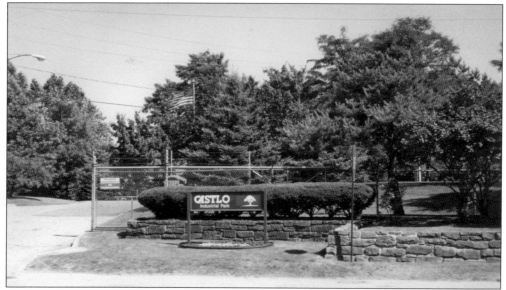

With a mission to clean the environment and to build the infrastructure for future projects, bridges, and roads, the CASTLO Community Development Improvement Corporation formed in 1978. It accepted the charge of improving and promoting the economic development of Struthers, Lowellville, and Campbell, and encompassed Poland and Coitsville Townships. Their comprehensive plan included adaptive reuse of existing buildings, demolition of functionally obsolete buildings, environmental remediation, and construction of new buildings. (Courtesy of Dan Mamula.)

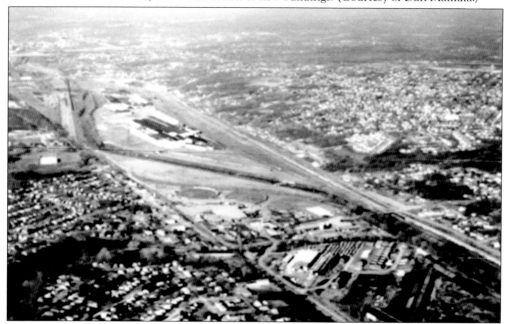

Black Monday was a defining moment, but not the final moment. After Black Monday, Struthers changed in the physical landscape and in demographics. The change also brought about opportunities for better health care and better quality of life. This city and its residents are gritty; they hang in there. "Struthers is a survivor," says former mayor Mamula. This 1992 aerial photograph shows the Struthers Campbell corridor. (Courtesy of Dan Mamula.)

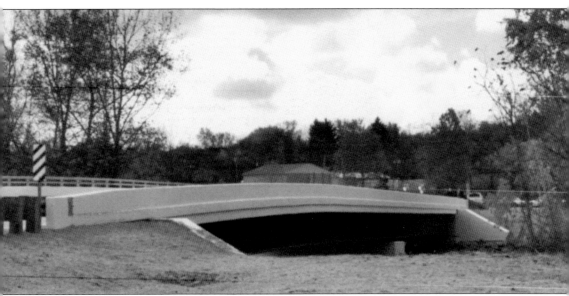

After the closing of the steel mills, the river was once again used as a pathway for redevelopment. In 1995, faced with the impact on the local economies and challenges that resulted from the demise of the steel industry, the City of Struthers and CASTLO founded the Mahoning River Corridor of Opportunity (MRCO). MRCO, a public-private partnership comprised of Struthers, Campbell, Youngstown, Mahoning County, CASTLO, Youngstown State University, the Eastgate Regional Council of Governments, the Regional Chamber, Ohio Environmental Protection Agency, US Environmental Protection Agency, and property owners, was formed to collaborate on facilitating the reclamation and redevelopment of 900 acres of brownfields along the Mahoning River between CASTLO in the east and the Youngstown Center Street Bridge in the west. Part of the infrastructure developed is the lower connector bridge from Struthers to Campbell, pictured here. (Courtesy of Dan Mamula.)

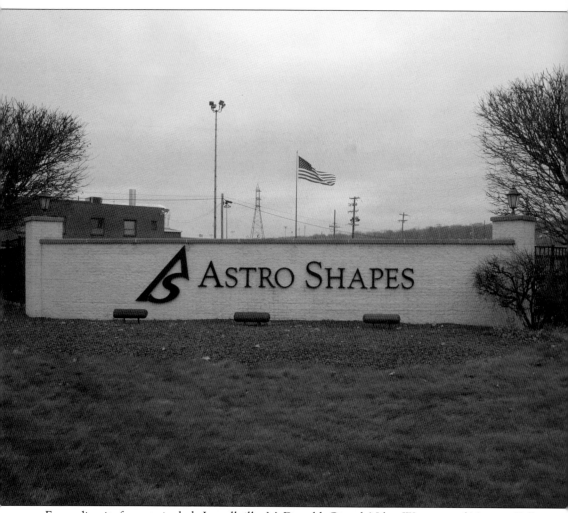

Expanding its focus to include Lowellville, McDonald, Girard, Niles, Warren, and Newton Falls in 2008, MRCO became the Mahoning River Corridor Initiative (MRCI), housed at Youngstown State University's Center for Urban and Regional Studies. It is one of the state's most well-known and respected planning initiatives. Since its inception, partnering communities have secured over $40 million in funding to remediate sites and improve infrastructure in pursuing redevelopment in the river corridor. In 2012, it merged with the Western Reserve Port Authority. The agreement brings together two of the region's most innovative and dynamic economic development agencies in an effort to strengthen their ability to secure the funding needed to convert plans into tangible projects. Astro Shapes, an aluminum extrusion facility, is not only a major partner in the redevelopment work but employs over 400 people as Struthers's largest employer. Here is the entrance to the plant in 2014. (Courtesy of Frank Marr.)

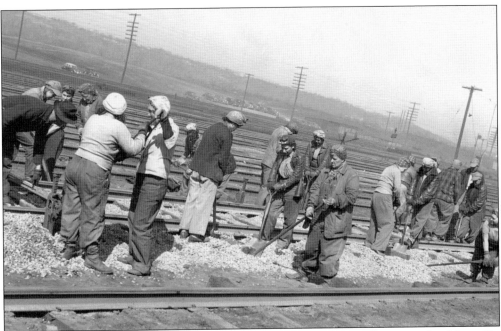

On the following pages are a sampling of the work life of Struthers residents outside of the mills. There were a variety of groceries, family-owned stores, restaurants and bars, and gas stations that nurtured the town. Pictured above in 1943, Struthers resident Delores Vlosich, center front, works on the railroad during World War II.

The first gas station in Struthers was opened by Cecil McHenry at Bridge and Liberty Streets about 1920. According to *Edmunds Auto Observer*, gas cost an average of 20¢ per gallon in the United States in 1920 and was no bargain. The owner of a Model T, which got 15 miles per gallon and traveled 10,000 miles per year, would expect to pay $133 in annual gas costs. At that time, the average American made $1,500 per year. This was just under 10 percent of annual income.

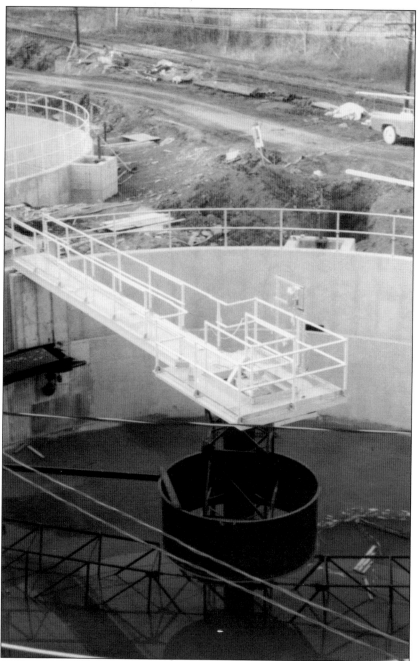

Struthers Waste Water Treatment Plant took 10 years of planning before it was completed in 1961 under Mayor Harold Milligan. Located on Lowellville Road on property previously owned by the Youngstown Sheet & Tube Company and Sharon Steel, its land was deeded to the City of Struthers for $1. This project tied together seven major raw sewage lines that emptied into the Mahoning River. In the mid-1980s and 1990s, the city invested millions of dollars to build a secondary treatment plant, replacing and upgrading much of the sewer system. It is now known as the Struthers Water Pollution Control Facility. Pictured here is the primary clarifier, which separates solids from water. (Courtesy of Paul Ringos.)

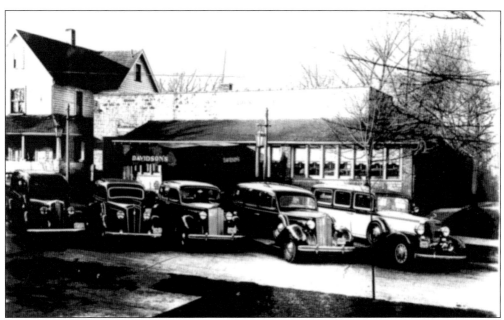

Founded in Lowellville in 1896 by Dan Davidson and Jesse Cunningham, the Davidson-Becker Funeral Home is the oldest in Struthers, opening on Bridge Street in 1907. In the early 1910s, it was the first in the area to use automobiles for funeral processions. It moved to its current location on Poland Avenue and Spring Street in 1913. In 1925, the owners constructed the first freestanding building used exclusively as a funeral home in this area. Dan Becker had returned home after serving as a paratrooper and entered the family business in 1961. In 1999, his daughter Kelly, pictured below reading to Janine Smrek's second-graders, became president and is the fourth generation to lead this independent funeral home.

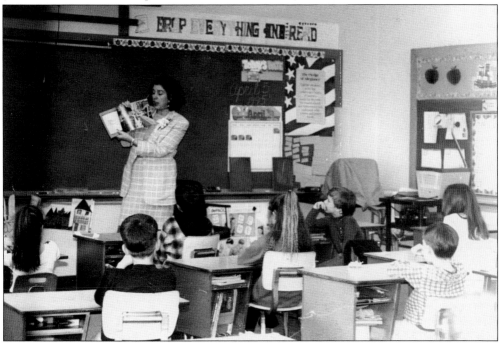

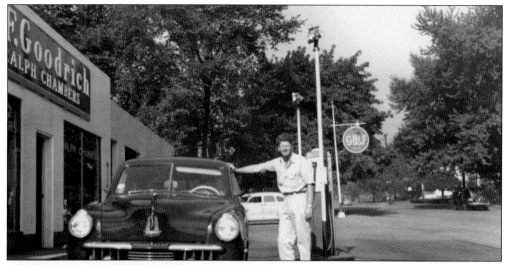

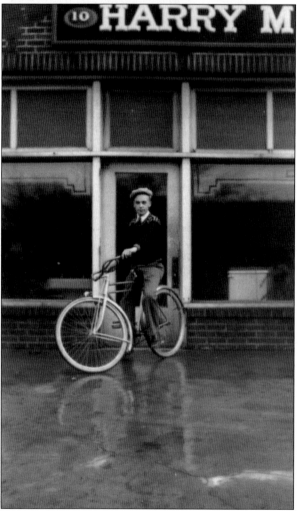

In 1948, Ralph Chambers opened the BF Goodrich store at Fifth and Elm Streets. Gulf gas was pumped, and a four-bay garage serviced cars. According to his daughter June Stoeber, "coming for gas was a lasting visit. It was a man's wonderland inside with outboard motors, fishing rods and reels, tackle, rifles and ammunition. He would hold a red or blue Schwinn bike for a few dollars for a child's special gift." This early installment plan or "layaway" allowed parents to pay a little each month until the bike was paid for. Chambers is pictured above outside of his business in 1948. Myron Wormley is at left in an undated photograph outside the family plumbing business on Spring Street. (Above, courtesy of June Stoeber; left, courtesy of Gregg Wormley.)

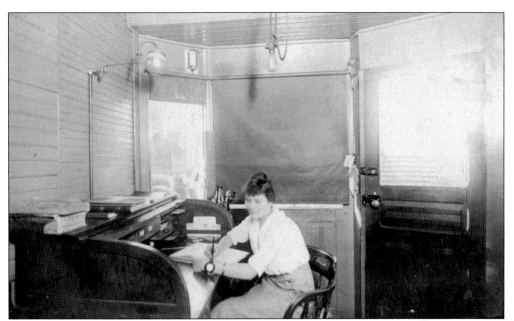

In the early 1900s, Wormley's and Shelton Plumbing were both located on State Street in downtown Struthers. Carrie Godward is pictured above in the office of Shelton Plumbing in 1915. Later, Wormley's moved to Poland Avenue and Spring Street. Seen below in an early showroom, the group on the far right includes Grace, Myron, and Harry Wormley; the man and woman on the left are unidentified. Harry Wormley started the business. When his son Myron joined him, it became Wormley and Son Plumbing. Eventually, Jack, Myron's son, ran it until the mid-1980s, when big-box stores moved into nearby towns. People still remember, "If you can't find it or get it fixed at Wormley's, you better get a new one." (Above, courtesy of Bill Allen; below, courtesy of Gregg Wormley.)

Smitty's Atlantic Service Station, operated by owner Elmer Smith from 1959 to 1965, was located at Fifth and Elm Streets adjacent to Isaly's and across from Paul Egoff's Gulf Station. In the image at left, Smith (right) is pictured with Buzz Replogle in 1952 at Rep's Motors, a Chrysler and Plymouth dealership on Fifth Street. Smitty's is pictured below in the winter, with Isaly's visible on the right. (Both, courtesy of Dennis Smith.)

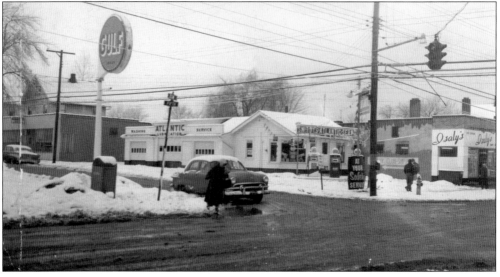

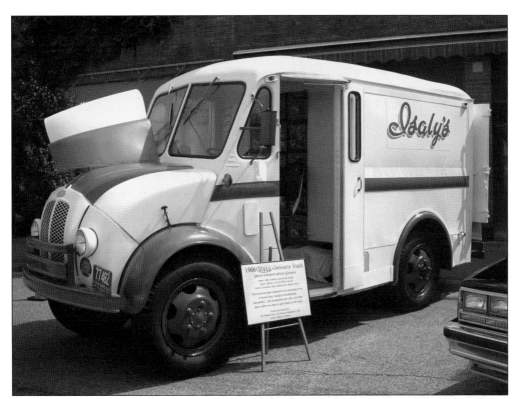

Isaly's stores and trucks bring back memories of chipped ham and skyscraper ice cream cones. Here is one of the original trucks of the Isaly's fleet with a mock-up of groceries. These trucks made home deliveries in the days when milk boxes were left on front porches to receive them. Money was put in the box with the order of what was needed, and the Isaly's deliveryman would leave the dairy products. Regionally, the dairy is also remembered as the "Big Isaly's" since it could be seen from Interstate 680 in Youngstown. (Both, courtesy of Frank Marr.)

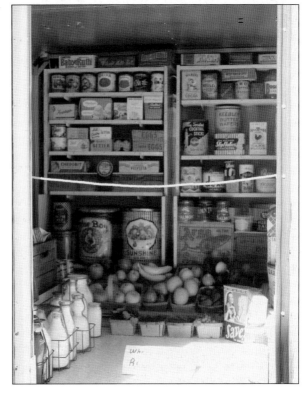

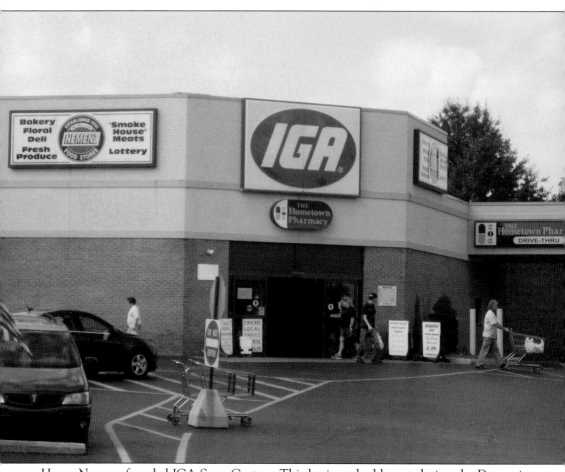

Henry Nemenz founded IGA SuperCenters. This business had begun during the Depression when his father, Gustav, sold meats from his home in North Lima. The younger Nemenz went into business for himself in 1976, opening a store in Boardman. The Struthers store at 655 Creed Street opened in 1980. In 2012, it received the Ohio Grocers Association Pinnacle Award. Then in 2014, activating the liquor license that came with the store when it was purchased, Nemenz IGA became the first area grocery store with a bar inside, serving draft beer and wine. (Courtesy of Debbie Zetts.)

Robert Kurtz, pictured at right, founded Kurtz Tool and Die Company on State Street in the basement of his home in 1960. While working for Metal Carbide during the day, he built dies in the evening. Generally customized, dies are specialized tools used in manufacturing to cut or shape materials using a press. Within a year, his contracts had increased to the point that he rented a shop in Poland and worked full time to grow and build the business. In 1962, he purchased the building on State Street in Struthers. Today, his son and grandson run the company supplying dies for many industries nationwide. Below are Robert Junior and his son Robbie in 2014. (Both, courtesy of Bob Kurtz and Judy Kurtz Sabula.)

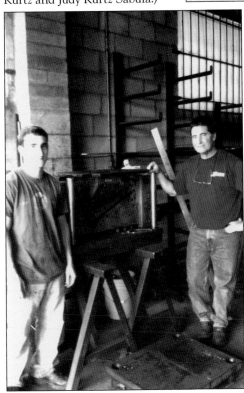

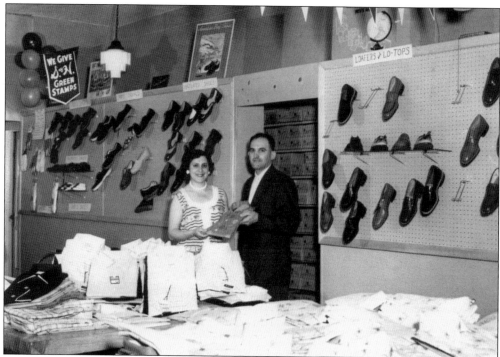

Paul and Marian Paris are seen above at Paris Men's Shop in 1957. James Paris started the business but died in 1945 while his son Paul was serving in the Navy during World War II. Paul returned home and oversaw the store's evolution into a full-line men's clothing store, located at 182 South Bridge Street from the mid-1930s until it moved two storefronts away in 1956. Paris's was known for fine clothing, quality workmanship, and great service. This block, completely rebuilt after a 1932 fire, also housed Dairyland Restaurant, Meine's Flower Shop, LaFrance Dry Cleaners, and Thatcher Heating. Paris Men's Shop closed in 1986, and Paul died in 2013 at the age of 91. (Both, courtesy of Joe Paris.)

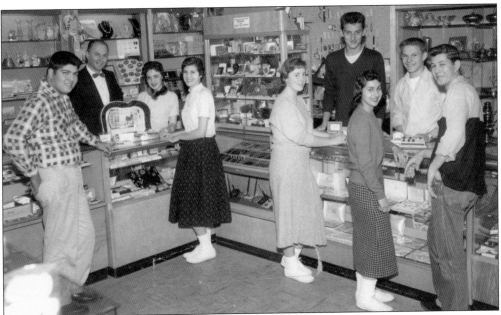

Robert Komara recalls his dad's story of starting Komara Jewelers. At age 13, the senior Robert Komara came from Czechoslovakia with his father and stepmother. Not able to finish high school because of finances, he joined the Army and was severely injured in World War II. In 1948, after surgeries and rehabilitation, he attended trade school and started a watch repair business. Although he had little money, some of the vendors passing through town allowed him to have watches and jewelry on consignment. He built his business. Through the years, Komara Jewelers had several Struthers locations, including the corner of State and Bridge Streets, farther up State Street, and the Fifth Street Plaza. Pictured below are, from left to right, (first row) Marge Babik, Michael Carlozzi, and Agnes Toth; (second row) Robert Komara, Barbara Cardarelli, Stephen Komara, Pat Sabol, and Thomas Komara. (Both, courtesy of Robert Komara.)

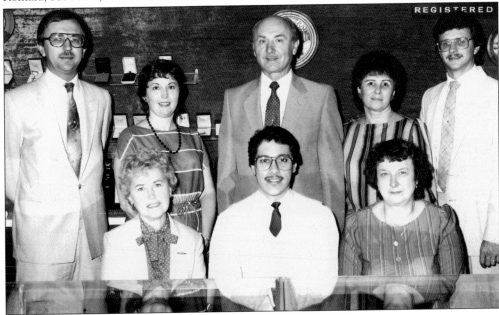

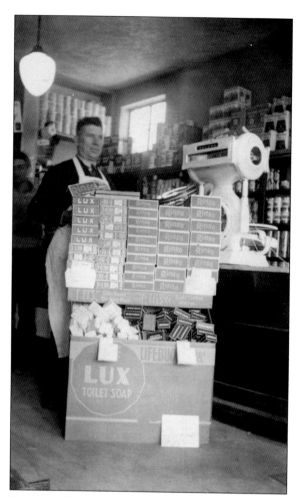

Many family-owned groceries did business in Struthers, but only a few appear in this book. Doris Matricardi remembers her father's store, Kopp's Market, at 114 Sexton Street. John Kopp's customers built the store to pay off their grocery bills, and it operated from 1932 to 1969. John smoked his own hams and homemade kielbasa in his Campbell store. John is seen at left about 1935 inside his store. The photograph below was taken outside the store in 1989. (Both, courtesy of Doris Matricardi.)

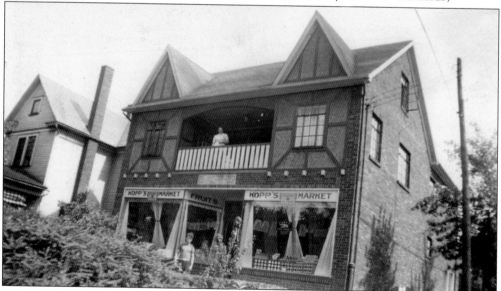

The original Rip's Restaurant was opened in 1933 by George Repasky at 114 Bridge Street and received the first Struthers liquor license once Prohibition ended. Always doing a brisk business, like many bars, Rip's cashed mill workers' checks on payday. George Repasky was shot in the leg on his son's 15th birthday in 1935 as he came in to open the bar. The bullet tore through a major blood vessel, and he died. Although in possession of $1,000 in cash, only $200 was taken. This large amount of money was on hand to cash the mill workers' checks. Although three arrests were made, there was never a conviction. Rip's, located on Youngstown-Poland Road since 1958, is still a family-owned business. Managed and operated by Don and Marilyn Watt, other family members are Ray Repasky, Janet Morris, and Patty Norman. (Both, courtesy of Janet Morris.)

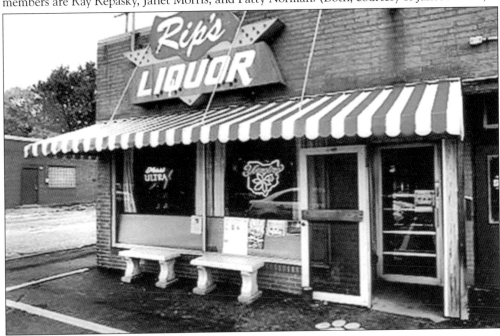

3R Auto Specialties is an auto body paint and repair shop on State Street, located there since about 1980. The three R's, Robert, Robert, and Ronald, are the father and sons of the Boano family. Owned by son Robert, this business is built on land that belonged to his great-grandparents. Their house was destroyed by fire in the 1930s, but the property remained in the family, eventually giving a home to this business. From left to right are Robert Sr., Ronald, and Robert Jr., owner. Below, Struthers Auto Service on Broad Street was owned and operated by Sam Zarlingo. Zarlingo's granddaughter Annette donated pictures and memorabilia to the historical society as a legacy and to fulfill a promise to her grandmother. (Left, courtesy of Theresa Boano; below, courtesy of Annette Todeska Ciccoelli.)

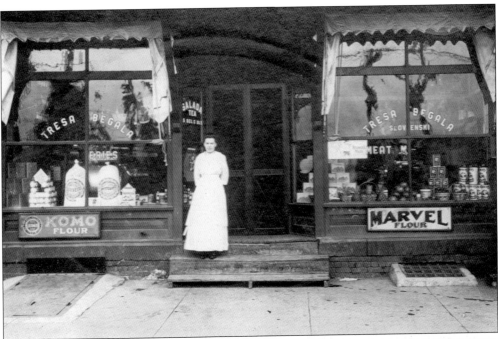

Tresa Begala's Grocery Store was located at 134 Broad Street from about 1905 until the late 1950s. Her granddaughter Susan Bonelli Missik remembers how this tiny woman could butcher meat as well as any man, swinging the cleaver and sawing through bones, but how business practically stopped when it was time to listen to her radio soap opera. She frequently extended credit to many customers during the Depression. During the blizzard of 1952, Begala's was one of the few stores in the county with milk to sell. Tresa's son-in-law Tony Bonelli, pictured at right with his daughter Susan outside their Washington Street home, trudged with a sled up North Bridge Street hill to Olenick's Dairy on State Route 616 to get the milk. (Both, courtesy of Sue Missik.)

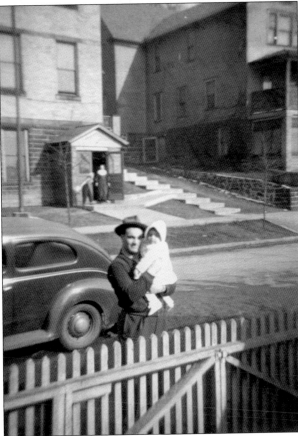

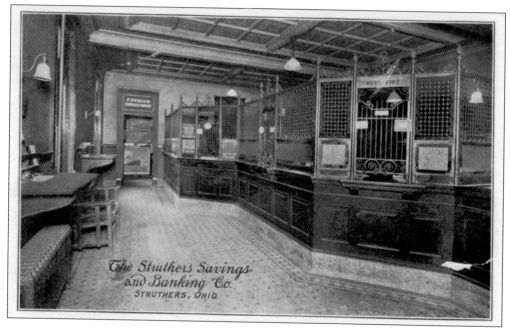

These are early pictures of the inside of Struthers Savings and Banking Company. The bank opened in 1902 but closed in 1920 for mismanagement and misappropriation of funds. It reopened later that same year as the Dollar Savings and Trust Company, remaining downtown until 2003. Later, Selah's Restaurant opened in that location and is still there today. History and memories in this brief business section are like Albert Einstein's words—"Not everything that can be measured is important and not everything that is important can be measured."

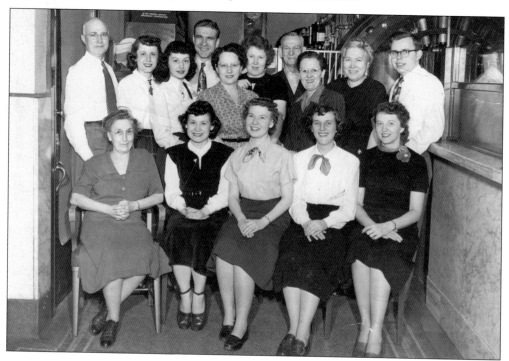

Six

Playing for Sport and Fun

*There's a big difference between marching to a different drummer
and having no sense of rhythm whatsoever.*

—unknown

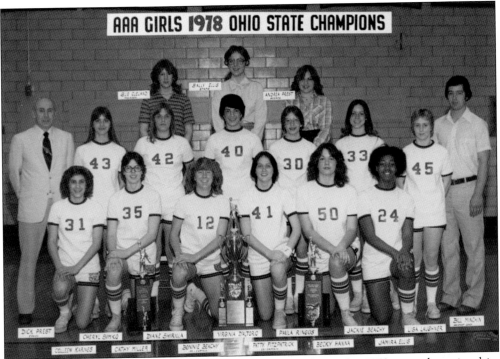

The Struthers women's basketball team had rhythm and won the 1978 state championship.
Players are, from left to right, (first row) Colleen Karnes, Cathy Miller, co-captain Bonnie Beachy,
co-captain Patty Fitzpatrick, Becky Hanna, and Jamira Ellis; (second row) coach Dick Prest,
Cheryl Simko, Diane Shirilla, Virginia D'Altorio, Paula Ringos, Jackie Beachy, Lisa Laughner,
and assistant coach Bill Minchin; (third row) Sue Cleland, Sally Ellis, and Andrea Prest.

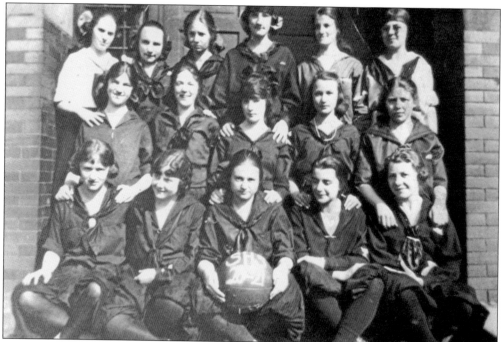

Although the 1978 women's team has the only state championship banner hanging in the field house, there were other great teams earlier, including the 1925 team that also won a state championship. However, at that time, it was not a tournament sanctioned by the Ohio High School Athletic Association, so there is no banner. Shown above is the 1920–1921 team and below is the 1927–1928 team. Both played in state and national tournaments with success. During this era, the women played with six players, three forwards and three guards, and only the forwards were allowed to shoot baskets. Below, the last player on the right in the last row is Ann Roskos, who was inducted into the Struthers High School All Sports Hall of Fame in 1988.

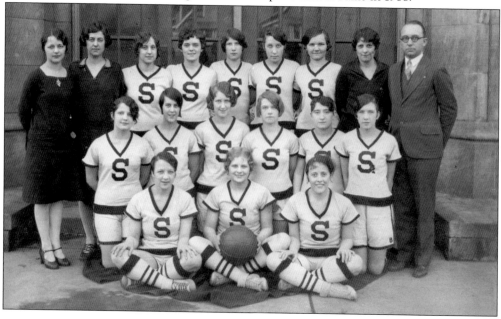

In 1977, Bonnie Beachy was the first Struthers basketball player, male or female, to score 1,000 career points. She remains the leading all-time scorer with 1,448 career points. This was accomplished before the three-point shot. Inducted into the All Sports Hall of Fame at Struthers High School, she averaged 24 points and 16 rebounds per game, shooting 50 percent from the field and 70 percent from the foul line in her senior year. She was named the state tournament's most valuable player. Her uniform numbers 12 and 13 were retired when she graduated. She went on to success at Kent State University, where she is still the leading scorer with 2,017 points. This picture was taken during her junior year; she wore the number 32 that year. She is seen running out before the 1977 district finals in Hubbard. Cindy Colucci leads the way, while assistant coach Debbie Volsko holds the door. (Courtesy of Debbie Volsko.)

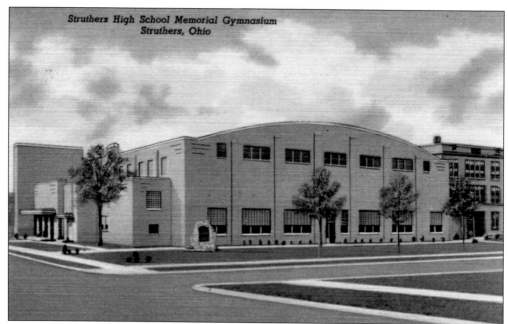

Struthers High School Memorial Gymnasium
Struthers, Ohio

Calling the Struthers Memorial Gymnasium their home court, others who have scored 1,000 points in their Wildcat basketball careers are Missy Gentile (1988), Jim Fox (1993), Roseann Scott (1996), Christie Zetts (1998), Rick McFadden (1999), Dana Matthews (2004), Ashley Galbraith (2008), Nate Jacubec (2011), Jake Jacubec (2012), and McKenna Shives (2014). The gymnasium was dedicated in 1951 in memory of those citizens who lost their lives in World War II. Once featured in a 1961 episode of the television show *Route 66*, it has 1,008 permanent stadium seats, 2,000 permanent bench seats, and 550 men's lockers with eight showers and the same for women. It also houses the school's music department. Many remember attending concerts, the Aut Mori Grotto Circus, Golden Gloves tournaments, professional fights, and early Youngstown State basketball games there. It continues to host high school men's and women's district tournaments.

The March 1963 cover of *Boys' Life*, an official publication of the Boy Scouts of America, featured the first undefeated basketball season in Struthers High School history with co-captains John Myers (No. 40) and Richie Coppola (No. 24) as they begin the final game of the season in a packed field house against perpetual rival Campbell. Coach George Kerlek, assistant coach John McBride, and trainer Charles Sauer helped lead this team to 18 straight wins. Their team song was "Sweet Georgia Brown." Players pictured below are, from left to right, (first row) Rich Huzicko, Richard Karis, John Colick, Tony Matlak, Richie Coppola, Squint Myers, Tony Fire, Joe Smolko, and Ron Lynn; (second row) managers Bill Bogan, Carmen Pitzula, Charles Gabriel, and Joe Opsitnik. Later, the 1980–1981 men's basketball team was undefeated and the Mahoning Valley Conference champions. (Right, courtesy of *Boys' Life*; below, courtesy of Frank Marr.)

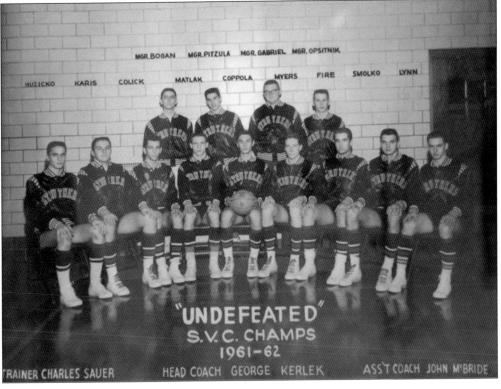

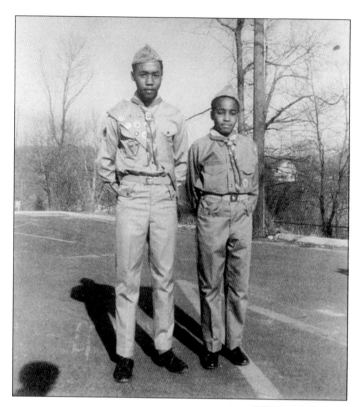

This is a 1971 picture of Brantley brothers Juan and Keith in their scouting uniforms; they achieved Eagle Scout honors. They were excellent students, musicians, and athletes. On January 10, 1975, Juan died of a previously undetected heart problem while playing on the high school basketball team in the gymnasium. After his older brother's death, Keith was determined to become a doctor to help others who might have the same problem. Today, he is a well-respected cardiologist in Zanesville, Ohio. (Courtesy of Kathy Brantley.)

The high school sports medicine clinic is named after John Daliman, an outstanding educator who taught math and science at the high-school and junior-high levels. Daliman was a lifelong Struthers resident, leaving only to serve in the Marines in World War II and attend South Dakota State University. He coached football, baseball, and track; was the athletic trainer and equipment manager; and in 1985, was inducted into the Struthers All Sports Hall of Fame. (Courtesy of J.P. Daliman and Marianne Daliman Kieffer.)

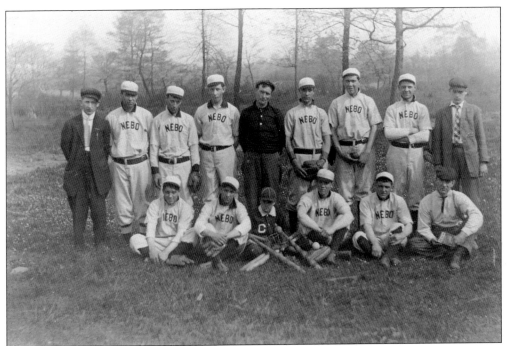

An early Nebo baseball team is pictured above in an undated photograph. At right, Bob Raybuck, playing high school baseball from 1946 to 1949, lost only three games and led the team to the Mahoning Valley championships for two years. He also earned letters in football and basketball and was inducted into the Struthers All Sports Hall of Fame in 1985. In this picture, Ray Swansinger, another Hall-of-Famer but for track, presents him with the game ball after his no-hitter in 1949 against Girard. (Right, courtesy of Terry Stocker.)

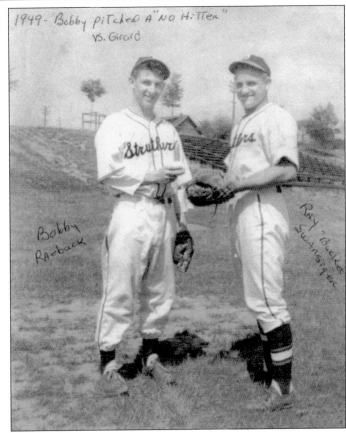

"This park is the inheritance for our youth's future," said Bob Cene. These words are engraved at the park that bears his name in downtown Struthers just outside of the business district. Bob Cene Park, established in 1995, is built on the former coke works site. As one of the top amateur facilities in the region, it is a great spot to enjoy a game and hosts the National Amateur Baseball Federation's World Series. Below, Mayor Terry Stocker throws out the first pitch in the World Series in 2013. The three-field lit baseball complex serves as home field for the Youngstown Class B Baseball League; Youngstown State University Penguins; and Struthers, Mooney, Ursuline, and Lowellville high school teams. (Both, courtesy of Frank Marr.)

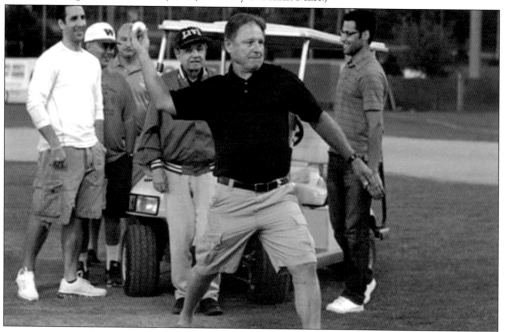

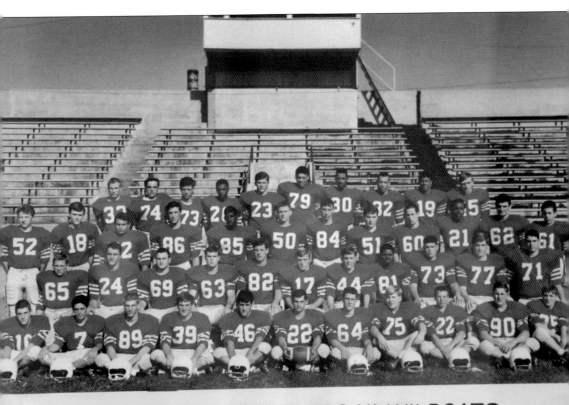

UNDEFEATED STRUTHERS HI WILDCATS
1968–STEEL VALLEY CHAMPIONS–1968
RANKED 5th IN STATE OF OHIO

Row 1: L to R: M. Annicñine, B. Cabuno, P. Softich, G. Janecko, J. Gentile, D. Barone, C. Pompeii, D. Young, P. Kasper, T. Sueda, M. Conn
Row 2: J. Balestra, G. Zetts, J. Visingardi, A. Artar, D. Morris, D. Ciontz, B. Pittman, A. Turner, D. Smith, D. Pittman, M. Sandine
Row 3: J. Wells, T. Marucci, J. Cantanzriti, R. Pisani, B. Ellis, J. Brennard, T. Zetts, R. Cleland, T. Munroe, P. Suber, D. Tombo, J. LoC
Row 4: J. Paulic, A. Papp, J. Pellice, A. Suber, T. Casey, C. Murphy, V. Murphy, V. Murphy, B. Murphy, R. Mogolich
BOB COMMINGS – HEAD COACH

The team pictures in the main lobby of Struthers High School are impressive. This rotunda documents the accomplishments of undefeated teams. They are from throughout the 20th century, and the legacy is continuing into the 21st century. For football, the undefeated squads are the teams of 1930, 1967, 1968, 1981, and 1982. This 1968 team was coached by Bob Commings and was ranked fifth in the state. Commings coached five seasons at Struthers, compiling a 50-16-4 record. He eventually went on to coach for five seasons at the University of Iowa, his alma mater. (Courtesy of Frank Marr.)

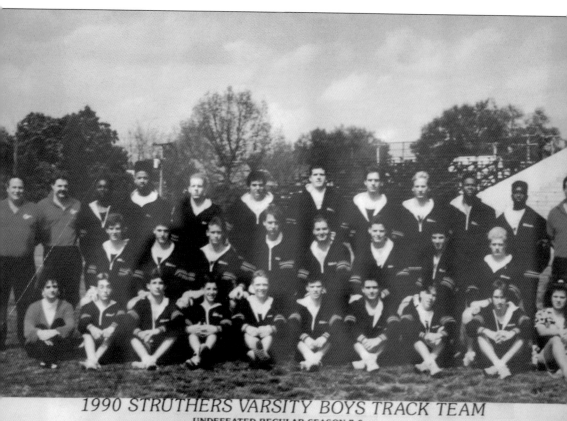

1990 STRUTHERS VARSITY BOYS TRACK TEAM
UNDEFEATED REGULAR SEASON 7-0

SITTING: S. Gettan, J. Lanzo, J. Loboy, C. Baber, B. J. Bergerone, E. Horvath, S. Patton, C. Pezzone

Row 2: B. Landie, T. Blazek, B. Blazek, J. Fox, D. Rakocy, S. Fire, J. White P. Klingensmith

Coach P. Valentino, Coach D. Weitzman, C. Strozier, D. Martin, M. Leonard, S. Bernard, J. Lanzo, J. Protain, B. Malatok, D. Taylor, D. Seaborne, Coach R. Conklin

The first undefeated men's track and field team was in 1990, pictured here. Other undefeated men's track and field teams are from 1991, 2003, and 2004; both the 1982 men's tennis team and the cross-country team were also undefeated. Another outstanding team to mention is the 2014 men's bowling team, who were runners-up in the state tournament. (Courtesy of Frank Marr.)

The high school entrance is now shared with the field house. In building the new high school, the Morrison Street entrance to the field house was closed. The old ticket and phone booths remain. The redesign showcases team trophies, 1,000-point scorers, and the All Sports Hall of Fame. Struthers graduate Nancy Tobias Knight is the school's first female athletic director, serving currently. She is working with school and community leaders to continue the selection and induction process for future Hall-of-Famers. Pictured above in 2000 are the old high school, field house, and a portion of the track; shown below in 2014 is the band shell. (Above, courtesy of Marian Kutlesa; below, courtesy of Frank Marr.)

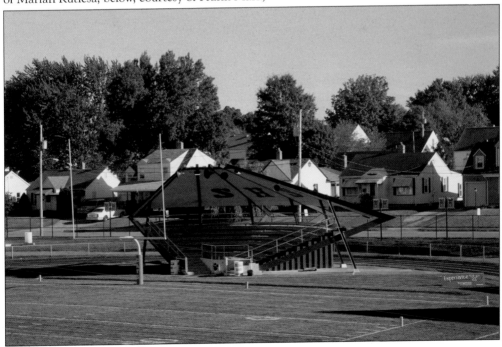

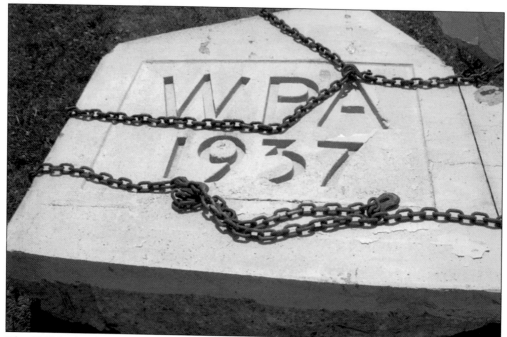

The 1937 high school football stadium cornerstone was removed while renovations took place in 1950. Major renovations occurred in 2007 through the generous financial support of Tony and Mary Lariccia. Lariccia requested that the field be renamed the Laddie J. Fedor field; Mary Lariccia said, "We should all strive to emulate his character." Fedor graduated from Struthers High School in 1942. He served in Patton's 3rd Army, seeing action in the Battle of the Bulge during World War II. Returning to Struthers, he was active in education as a teacher, principal, and superintendent of Struthers schools. He also served the city as the first tax commissioner. (Above, courtesy of Esther Watt; below, courtesy of Frank Marr.)

Early in the 20th century, sports were not the only entertainment in Struthers. There were also downtown theaters. Here are Bill O'Hara and Lillian Heckel around 1945 outside of the Ritz Theatre where O'Hara ushered and sold popcorn. Residents recall going to the movies there when tickets were 10¢. Paul Ringos remembers collecting empty bottles to return for the refund to get the money to take his date, Rose Banozic, to the movies. (Courtesy of Bill O'Hara.)

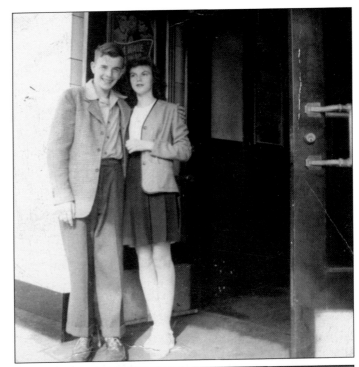

John Morell Jr. remembers the playground rides his dad, policeman John Morell, built for the family and neighborhood children in their north side backyard. In 1951, his dad's playground won first place over more than 90 entries in a contest sponsored by the Youngstown Playground Association. Besides the usual swings, sliding boards, and teeter-totters, it had an electric merry-go-round with a baby seat on one end and a horse seat on the other. Pictured is Jacquelyn Marie Morell Villio. (Courtesy of John Morell Jr.)

Bowladrome Lanes at 56 State Street opened in 1946. Thomas and Marge Janosik bought it in 1974 and continue to operate it. A community fun spot, it was the setting of two scenes in the 1978 Academy Award–winning film *The Deer Hunter* starring Robert De Niro and Meryl Streep. The scenes were filmed July 13, 1977, and 30 people from the Youngstown area, dressed in winter coats, appeared as extras. Julia Amicone remembers that De Niro was "down to earth and friendly." She also stated, "I didn't even know who he was then." He is pictured below with Amicone's daughter Cindy Butch Todd. (Above, courtesy of Frank Marr; below, courtesy of Julia Amicone.)

Play at its best is perfectly described in Mikhail Baryshnikov's words: "I do not try to dance better than anyone else. I only try to dance better than myself." *Struthers Revisited* is a scrapbook of things from the past with an eye to the 21st century. Above, Betty Kossick and Mary Emanuel pose at the entrance sign to Struthers from Poland on State Route 616. (Above, courtesy of Betty Kossick.)

BIBLIOGRAPHY

Beach, Patricia. *Struthers*. Charleston, SC: Arcadia Publishing, 2008.

Bruno, Robert. *Steelworker Alley: How Class Works in Youngstown*. Ithaca, NY: ILR Press, 1999.

Butler, Joseph. *History of Youngstown and the Mahoning Valley Ohio*. Chicago, IL: American Historical Society, 1921.

DeBlasio, Donna. *Youngstown*. Charleston, SC: Arcadia Publishing, 2013.

Kutlesa, Marian. *A History of Home*. Unpublished, Struthers Historical Society archives, 1986.

Mallery, Harry. *Bridge Street 1899*. Unpublished, Struthers Historical Society archives, 1971.

Struthers Bicentennial Committee. *Struthers, Ohio Cradle of Steel*. Struthers, OH: Struthers Bicentennial Committee, 1976.

Struthers Ohio Volunteer Fire Department. *Souvenir*. Struthers, OH: Struthers Ohio Volunteer Fire Department, 1910.

Struthers Total Environmental Education Program. *Struthers: Prologue-Epilogue*. Struthers, OH: Struthers Total Environmental Education Program, 1975.

Struthers Veterans and Civic Association Inc. *The Cradle of Steel, Struthers: Ohio 1804–1948*. Struthers, OH: Struthers Veterans and Civic Association Inc., 1948.

Youngstown Sheet & Tube Company. *Fifty Years in Steel: The Youngstown Sheet & Tube Company*. Struthers, OH: Youngstown Sheet & Tube Company, 1950.

About the Struthers Historical Society

The Struthers Historical Society began as an effort to preserve the stories and memorabilia that had been collected in Struthers for the country's bicentennial celebration in 1976. Financial support from individuals and the Struthers Rotary were instrumental in starting the society and in sustaining it. In 1986, heirs of Alexander Frankfort, Struthers's last surviving Civil War veteran, donated the home on Terrace Street to the society to house its expanding permanent collection.

Membership is open to all who are interested in preserving the history of Struthers. To visit or for more information, contact Marian Kutlesa at 330-755-7189.

The author's proceeds from the sale of this book will help the Struthers Historical Society in its mission to safeguard our past for the future. Plans have also begun to digitize portions of the society's collection.

DISCOVER THOUSANDS OF LOCAL HISTORY BOOKS
FEATURING MILLIONS OF VINTAGE IMAGES

Arcadia Publishing, the leading local history publisher in the United States, is committed to making history accessible and meaningful through publishing books that celebrate and preserve the heritage of America's people and places.

Find more books like this at
www.arcadiapublishing.com

Search for your hometown history, your old stomping grounds, and even your favorite sports team.

Consistent with our mission to preserve history on a local level, this book was printed in South Carolina on American-made paper and manufactured entirely in the United States. Products carrying the accredited Forest Stewardship Council (FSC) label are printed on 100 percent FSC-certified paper.

MADE IN THE USA